Why Women Act *Foolish*

Dr. Veronica G. Bee

ISBN 978-1-64569-861-6 (paperback)
ISBN 978-1-09800-868-0 (hardcover)
ISBN 978-1-64569-862-3 (digital)

Christian Faith Publishing, Inc.
832 Park Avenue
Meadville, PA 16335
www.christianfaithpublishing.com

Printed in the United States of America

Contents

Foreword

Many can talk it, but not many can walk it. Allow this book to adrenalize your mind as you peruse every page. These writings were birthed out of years of experience, test, and trials of my lovely wife, Dr. Veronica Genice Bee. I have known her for over forty-six years and counting. She is the epitome of a God-fearing woman who has sold out her life to help others achieve and fulfill their dreams and callings.

Now, if a woman is acting *foolish*, there is a reason or reasons behind it. I am 100 percent sure that every one of us would like to find out why a woman is acting *foolish*.

Why women act *foolish* could be a question or a statement ready for facts of knowledge to be answered. At first, you may think every woman in the universe need to read this book; however, as you read further, you will see that this book is for every man and woman who need help with building a strong Godly relationship. In this book, Dr. Bee will show how we as a society has gotten off track because we fail to carry out our roles and assignments while here on earth. We understand that all of us were created for a reason; however, many never discover what they were designed or engineered to do by God.

If you have never heard her speak, her teachings are phenomenal! Rest assured, Dr. Veronica will keep it *100* in this book! You will discover from start to finish that this book is a household manuscript for every home on earth. I can see women groups forming to discuss the enlightenment of nuggets written in this book. I can see men secretly carrying out the revelation they have received from this book. I can see those in the unmarried state getting a head start on

their newly found relationships. I can see husbands and wives taking their relationships to another level, which they did not think they could ever achieve. I truly believe the impossibles are going to be made possible with this writing. So allow the words to soothe, melt, and change your life for the better and forever.

It gives me great pleasure and extreme delight to foreword this book because I believe with all my heart that many will benefit from the shared words written in it. I am her one and only husband, and I approve of this book.

Winning Together!

Bishop, Dr. Harvey B. Bee
The Winning Church
621 Walnut Street
Warner Robins, GA 31093
winning.church

Acknowledgments

I am humbled and grateful that God has allowed me to write such a timely book for such a time as this. My gratitude to our Lord and Savior, Jesus Christ, who has blessed us to live and become contributors to the Kingdom of God.

Special thanks to the love of my heart, my husband and Pastor, Bishop Dr. Harvey Bee; my handsome son, Jarius; my lovely daughter, Mira; and my awesome son, Carlos, who are the paragon of a great family.

Thanks to my father, Bishop James H. Brown Jr.; my late mother, Claydes Brown; my father-in-love Bishop Wesley Bee Jr.; my late mother-in-love, Earnestine P. Bee; my father-in-love Burley Adams Jr.; my spiritual mother, Gloria Reid; my late spiritual father, Bishop Willie L. Reid Sr.; my spiritual father, Dr. Dave Wilcoxson; my spiritual mother, Ann Wilcoxson; my awesome friends Lauro and Peggy Garner, and Reginald and Lori Ray, for being great examples of virtue and trustworthiness.

Thanks to my three brothers and my one and only dear sister Kathy, who help developed me. We had an awesome childhood together!

Also, thanks to my Amazing Church Family (The Winning Church), Awesome School (The Winning Academy) who love me and help fulfill my life every day.

A special thanks in advance to you, all the readers, for investing in me and investing in yourselves. I believe after reading and applying these nuggets in this book, your life will never be the same. I bless God for your new life in Christ Jesus!

Preface

*Every wise woman buildeth her house: but the
foolish plucketh it down with her hands.*

—Proverbs 14:1

I must say that this book is written out of my heart and passion
because of all the issues that women universally face in life. I have
counseled or given spiritual advice to countless Women of God who
are hurting, damaged, and confused about their purpose on earth.

I do not claim to have all the answers when it comes to the
problems that all women face, but I do know that if you would allow
God to minister to your heart, He's the one that has all the answers.
Who The Son sets free is free indeed. Free so that you can help set
someone else free. Remember, "Hurt people hurt people, but healed
people heal people." God is there to comfort, strengthen, guide, and
lead you. He is a problem solver, a mind regulator, and a burden
bearer.

Even though my audience may be broader, I want to mainly
address the Body of Christ. The Body of Christ is now in an era
where many don't know the plans and purposes for their lives. Before
God designed you, He had a well thought-out plan for you. Thoughts
of hope and peace. We are here by divine order from God. In other
words, you are a special order and a special delivery. You are here
to change the world. God has an assignment on your life, and He
expects you to live out the vision He has planned for you.

Men and women's roles have changed over the course of the years. We as believers have become susceptible to our culture and taken on the likeness of this present world. We have allowed our culture to dictate to us "what's in and what's out." God saved us to become more like Him and less like the world. God want us as believers to have our own identity in Christ and become conformed to the image of Him.

Roman 12:2 says, "And do not be conformed to this world, but be transformed by the renewing of your mind, that you may prove what is that good and acceptable and perfect will of God."

For all believers, we must live a life that will be pleasing to God and Him only. Our lifestyle must express complete devotion to the Lord. We were born again to stand out and not blend in with the world.

As a believer, our life must be molded by the Word of God, not the peer pressure of this world, or from our families, friends, and coworkers. Our mind have to be renewed day after day to help our mind-set shift from worldliness to godliness! A transformation will take place when we feed our spiritual-man more and starve out our fleshly-man. A new way of thinking will only come from being filled with the Holy Spirit and being faithful to God in prayer, praise, and being persistent.

One of my main objectives is to say what God has said about man and woman and show how we ought to carry out the plan of God for our lives. It's not about our opinions or feelings, but it's about what has already been spoken about our purpose here on planet earth.

According to statistics, we have more women than we have men on planet earth. The Word of God says there will be seven women to one man. Let's take a look at the scriptures.

*And in that day **seven women** shall take hold of **one man**, saying, We will eat our own bread, and wear our own apparel: only let us be called by thy name, to take away our reproach. (Isa. 4:1)*

Meaning that when the Israelites went to war (men only), a lot of men were killed off. Because of this, many wives would have to fend for themselves. There was not enough men for the widow women to marry. This is when men decided that they can have more than one wife. Remember, this was man's idea and not God's. We can only have one husband and one wife according to the Word of God.

Since there were not enough men for all the women, the women started saying, "We will eat our own bread and wear our own apparel." Now this is an interesting statement. Let's look at this a little deeper. The men were the ones who would provide for the wives, so as the men died off, the women had to pick up the slack and provide for themselves if no other man married them. Nothing wrong with that, but when this started happening, the women got to a place where they thought that if they can provide for themselves, then what is the use for a man? That's why you have women saying, "I don't need a man" or "a man can't do nothing for me, I got this."

God never intended for us as women to think this way. We are the weaker vessel and can't handle the load and pressures of life alone.

Women are basically taking over in every profession as well as in their homes! They are CEOs, doctors, lawyers, pastors, and so much more. Nothing is wrong with this in their right perspective. God want us to prosper in every area of our lives. For many women, when we become successful, we basically take it to another level with a hidden agenda.

Pretty much women feel that we can do anything a man can do and more. And sad to say, men seem to be okay with that. Some women think that men are useless and not needed and that they can replace the man altogether.

However, I find today that women who are successful as a whole feel like they can call all the shots because they make more money or their own money. They quickly forget that there is still an order that God has ordained from the beginning. There is nothing wrong with being successful, but we can't let success pull us out of the will of God: *"Thinking yourself to be something, when you are nothing, deceiving yourself"* (Gal. 6:3, ESV).

Remember: money, power, and prestige does not mean anything with God if you are not in the will of God. *"What does it profit a man to gain the whole world but loses his on soul" (Mark 8:36, ESV).*

Are We in Our Rightful Position?

I want many to know that I'm strong in the Lord and the Power of His Might. I believe God's Word is the Absolute Authority, and the Word is Lord over my life. I do not want anyone to think that this book is about how to keep the women down and make them feel insignificant. This book is to help us as women to become a wise woman that builds her house and not a *foolish* woman who tears it down.

Yes, I make my own money, have my own goals and dreams. God has richly blessed my amazing husband (Bishop Dr. H. B. Bee) whom I absolutely love very much and I to have a very successful ministry and school together. We give God glory and honor for allowing us to be Partners In Christ, and I must say we make an awesome team together.

We work together every day, and we keep each other on the up and up daily. No matter whether we are dealing with church or school business, I know my role and he knows his. We are one, and we are stronger together.

Therefore, I'm not trying to keep you ignorant or in bondage as a woman of God. Back in the day, our society would call it barefoot and pregnant. This book is to empower, enlighten, and expand you to become better and greater for the Kingdom of God!

I pray that this book will help us all become better husbands and wives, fathers and mothers, brother and sisters as God has ordained from the beginning.

A survey shows that many women are bitter, angry, depressed, oppressed, and just plain mad about life!

Most women in the day that we live in are the most miserable creatures on earth. The married women want to be free, and the single women want to be married. Regardless of the state or status,

women are miserable because most of the time they don't know what they want or who they are. Some women have the attitude that they are sick and tired of this and sick and tired of that. Just plain mad about life.

Our mind-set or our thinking has to change if we want change.

Many women have not learned how to deal with issues too well. When issues are not dealt with as they come, the issues grow from a molehill to a mountain. When things are not dealt with, things fester in our heart and minds and causes us to think in a way that is not of God. We must learn to deal with issues as they come and be quick to handle the problems. The quicker you deal with the matters at hand, the better your life will become.

When things don't go our way, we as women tend to act *foolish* and overly think of ways that we can make things turn in our favor. We want things done our way, and we want it done now! The way we process things in life is based on our way of thinking.

Our thinking come from how we have seen our fathers treated our mothers growing up, how other husbands treat their wives, and how our own husbands treat us as wives.

We are *foolish* thinkers because of things we have experienced in our past, our upbringing (childhood), and or listening to other women who don't have a clue about who they are and trying to tell others who they are.

Because of the title of this book, many will believe that this book is just for women only, but ironically, this is a challenge for men to stand up, step up, rise up, and take their rightful place.

As quiet as it is kept, women need male leadership in their lives. Men are not as emotional as women. They tend to think things through without going through an emotional frenzy. Now, this does not make them superior. This is just how God made them.

God made men the responsible party and the leader of the home. Men may not like this role, but that is just the way it is; according to the scriptures, it was God's design. Everybody has a purpose attached to their name, and we have to find out what is God's plan for each of our lives.

As a Christian husband and father, you are there to provide your wife and children with spiritual leadership. Although your wife maybe fully equipped in the Word of God, it is still your responsibility as a husband to make sure your household get the proper teachings, remain strong in the faith, and carry out the training for his family. If not, wives will take the ball and run with it and leave the man behind.

MEN, you have a hand in how women act today!

> *But I want you to understand that the head of every man is Christ, the head of a wife is her husband, and the head of Christ is God.* (1 Cor. 11:3, ESV)

> *For the Husband is The Head of The Wife even as Christ is The Head of The Church, His body, and is Himself its Savior.* (Eph. 5:23, ESV)

Men, you determine whether or not you will have a *wise* woman or a *foolish* woman. It's all about how you invest in your wife and or daughter.

By nature, men are givers and women are receivers. Women take and men give, so then women take what is given to them and give it back multiplied whether it be good or bad. Men, whatever you are giving out, she will receive it and give it right back to you in a greater measure.

Chapter One

How Easy It Is for a Woman to Become Foolish Instead of Becoming Wise

Let's go back to the beginning:

> *And the LORD God took the man, and put him into the garden of Eden to dress it and to keep it.* **And the LORD God commanded the man,** *saying, Of every tree of the garden thou mayest freely eat: But of the tree of the knowledge of good and evil, thou shalt not eat of it: for in the day that thou eatest thereof thou shalt surely die. And the LORD God said, It is not good that the man should be alone; I will make him an help meet for him.* (Gen. 2:15–18)

Notice Eve did not come along until verse 22. All this time, God was speaking to Adam himself. God gave the command to Adam, the male man. There was a lack of communication in the Garden of Eden concerning Eve.

What do we hear from most women today? "My husband doesn't talk to me." God gave a commandment to the man, "*Of every tree of the garden thou mayest freely eat: But of the tree of the knowledge of good and evil, thou shalt not eat of it: for in the day that thou eatest thereof thou shalt surely die.*" And Eve came along in verse 22: "*And*

the rib, which the LORD God had taken from man, made he a woman, and brought her unto the man."

Something happened in the Garden of Eden that is happening in our time. What is it? Men are not giving women what God gave them, and that is the *Word of God!*

Reinforcement

It is implied that Eve did know about the fruit, but it is not recorded that the message from God was *reinforced* by Adam. That's what most women are missing today—*reinforcement!* Therefore, Eve took matters into her hands just as many women are doing today. What happened when Adam did not talk to his wife? She made a *foolish* choice.

God specifically told Adam what to do, but I'm sure he was so fascinated or overcome with *"bone of his bone and flesh of his flesh"* until he forgot. Does that sound familiar? Did you do what I asked you? "Honey, I forget." The beauty of the woman, the smoothness of her voice of what God commanded him not to do cause Adam to forget what to do.

In seeking to be wise, Eve made a *foolish* choice. She wanted to be wise, but she went about it the wrong way.

The Bible says that she want to be wise in Genesis 3:6:

> *And when the woman saw that the tree was good for food, and that it was pleasant to the eyes, and a tree to be desired to make one wise, she took of the fruit thereof, and did eat, and gave also unto her husband with her; and he did eat.*

She wanted to be wise, but Adam did not teach her God's Word. If Adam would have taught her, then they both could have become wise together in God. When the fruit was passed to her by the serpent, she passed it on to Adam, and he followed her.

Men, your wives need you to teach and lead them! God has given you the authority! In order for you to teach and lead, you have to be a student of the Word of God for yourself. Why are women more studious than men? Some men don't feel that it's necessary to be before God daily. They don't realize that this will be a huge benefit to them and also for their family. Reading, listening to the Word, and being held accountable will help steer men to be in their rightful place. Women do not want or need wimpy men leading them. They want strong and courageous men in their lives.

By nature, women are tenderhearted and compassionate, but many are bitter and bossy. Something happened that caused some women to act out. They have watched someone get treated wrong or have been mistreated or used themselves. Perhaps some have watched their mothers, grandmothers, or someone that they looked up to not give their husbands the respect they needed.

> *Now the serpent was more subtle than any beast of the field which the LORD God had made. And he said unto the woman, Yea, **hath God said**, Ye shall not eat of every tree of the garden? And the woman said unto the serpent, We may eat of the fruit of the trees of the garden: But of the fruit of the tree which is in the midst of the garden, **God hath said**, Ye shall not eat of it, neither shall ye touch it, lest ye die. And the serpent said unto the woman, Ye shall not surely die: For God doth know that in the day ye eat thereof, then your eyes shall be opened, and ye shall be as gods, knowing good and evil. And when the woman saw that the tree was good for food, and that it was pleasant to the eyes, and a tree to be desired to make one wise, she took of the fruit thereof, and did eat, **and gave also unto her husband with her; and he did eat**. And the eyes of them both were opened, and they knew that they were naked; and they sewed fig leaves together, and made themselves aprons.* (Gen. 3:1–7)

Know What God Has Said

Many times men and women do not obey God because they do not know what God has said or they simply just reject what God has said. When it comes to the Word of God, ignorance is no excuse to the law. Within God's Word, He gives us answers to all of life's test. You just have to study the Rule Book and know what God has said:

> About your life
> About your home
> About your children
> About your health
> About your finances
> About your spouse
> About your marriage
> About your friends
> About your relationships
> About your spiritual walk
> About your purpose
> About your vocation
> About your calling
> About your potential
> About your vision
> About your faith
> About your opportunities
> About your possibilities
> About your fulfillment
> About your destiny

Men are responsible for being examples in their home. *When men know that they are responsible and follow what God said, then they can become the great leader that God said that they can become.* Women can't follow someone who has no clue on where he's going. They can only say "follow the leader when the leader knows who he's following."

If Adam was responsible, he would have told Eve, "If I'm going to obey, you're going to obey. Whatever God said, that is what we are going to do."

Most women try to take authority that has not been given to them by God. Some have the tendency to overstep their boundaries, maybe because of lack of teaching or direct disobedience to the Word of God. The Word of God says that a woman is not to usurp authority over the man. This is to say that a woman is not to dominate her man!

I believe that God had an order in mind when He created man and woman. Somehow, things have become discombobulated and gotten out of order. Order was and is the way of God. If it's out of order, it is not God.

Let all things be done decently and in order.
(1 Cor. 14:40)

In our society, we have seen countless women dominating their husband because either the man is allowing it to be so or the woman thinks it is her place to do it. Either case, it is out of order according to the Word of God.

The women of the church are confusing what the world is doing with the way that God has ordained for a husband and wife's relationship is to be. If we want God's blessings on our relationships, we must follow the Master Architect; which is God.

Some things God did not require women to do; neither are women responsible to do it. But somehow women have taken the position of authority everywhere it is accepted. Beyond the physical ability to lead, God did not put that requirement on the woman to lead. Therefore, *it is not about ability, but responsibility.* If he's a man, don't let him off the hook! Allow him to lead; help him be the man!

Men are made to carry more because they are physically stronger, so they were built to carry the load (responsibility) of the family. Women were made to assist with the load. God made us to assist, not take over. According to the Word of God, we are the weaker vessel (1 Pet. 4:7). What does this really mean when we read this? Peter is

not trying to make us feel that we are less than a person and that we have to be inferior to our husbands or men in general. The truth of the matter is that men are generally stronger than women naturally. Therefore, men were designed to cover, shield, and protect his wife and family. That's why every man should treat and care for his wife as if she's his exquisite masterpiece. Yes, we should be put on the top shelf where no one but the one we belong to get to touch us.

I've been treated like a queen from day one by my husband. He has never mistreated me or disrespected me ever since we have been together. Yes, all these short years (thirty-six years and counting), I have never been mentally, verbally, or physically abused by my husband. Sure there have been times where we had disagreements, but my husband is not the argumentative type. He always brings solutions to our problems. Thank God! He has always be so kind-hearted, gentle, and sweet to me. I'm forever grateful to the Lord for allowing me to experience what real love truly is. I'm his diaphanous workmanship!

Identity

It makes women go crazy (*foolish*) when men do not know who they are or know what their purpose is. *Nations are lost because men do not know who they are.* "As the man goes, so goes the family, society, and the world." Men must have a clear idea of where they are going (vision); if not, many will endure the crisis that will affect generations and generations to come. Men are suffering a lost sense of identity, which is resulting in a downward spiral of imbalanced families here in America.

One reason for this progressive fall is that our society has conflicting signals about what it means to be man. Years ago, it was customary to pursuit work, marriage, and have a family to even be considered a man. But nowadays, many are questioning their roles and who they are as a man. This causes an inner uncertainty about what it means to be man, a husband, and a father.

On the other hand, when a man seeks to know and strive to be who and what God called him to be, we have women who have said, "I don't need a man." I say speak for yourself, I need mine. From the Bible, we understand that men need women and women need men; both are necessary to carry out the plan of God. It is God's design for a man and a woman to be together, multiply, and subdue the earth. A man is very necessary as well as a woman. One without the other is not beneficial; when God said it's not good that man should be alone, God made someone suitable for him—a woman!

It is very critical that a man know that he is very much needed and a woman equally as well. Each has a unique purpose and assignment that must be carried out as we seek God. Men and women must place value on each other and invest time, energy, and money on each other. A man and a woman make a powerful team together.

My question is, why are we as God's creation reevaluating what it means to be a man or a woman? Understanding that we are advancing rapidly and we are thriving in technology, why would we want to entertain changing what the creator has created? Our homes are deteriorating, and many are refusing to allow God to use them to fulfill their purpose. Divorce is the highest it's ever been for the believers. Our churches are weak because our homes are weak. Many want to redefine their own lives, forgetting that we don't belong to ourselves, but to God. The last time I checked, the creator of a thing has the right to say what and how the thing that was created is supposed to operate. God designed marriage, and anything that God designed, Satan wants to destroy or redefine the true meaning of marriage.

In our world, we have a whole lot of people with mistaken identity because they do not know or care to know their purpose. People have become victims of mistaken identity because we have taken the original intent of our identity and tried to change it into what we as humans (who are imperfect beings) into something other than what was designed from the beginning.

And the Lord God said, It is not good that the man should be alone; I will make him an help meet for him. And out of the ground the Lord God formed

*every beast of the field, and every fowl of the air; and brought them unto Adam to see what he would call them: and whatsoever Adam called every living creature, that was the name thereof. And Adam gave names to all cattle, and to the fowl of the air, and to every beast of the field; but for Adam there was not found an help meet for him. And the Lord God caused a deep sleep to fall upon Adam, and he slept: and he took one of his ribs, and closed up the flesh instead thereof; And the rib, which the Lord God had taken from man, made he a woman, and brought her unto the man. And Adam said, **This is now bone of my bones, and flesh of my flesh: she shall be called Woman**, because she was taken out of Man.* (Gen. 2:18–23)

When a man knows his identity, he is able to aid the woman into her true identity. He is able to speak into her life as Adam did in Genesis chapter 2 and tell her who she is. Whatever he says she is, that is what she becomes! First, he lets everyone know that she is a part of him. What I am, she is. She comes from my innermost being. She's my prime rib! She's the rib that protects my heart! She came out of me to help me, thus helping me inside and out.

It is very difficult for women to act *foolish* when their men know who they are. They will begin to speak over and in their wives' life, and they will begin to know who and what their purpose is. This is how they both will fulfill their purpose for God.

Communication

Men, you have to talk to your wives! They need you to speak a Word into their lives daily. Wives strive off words from their husbands. You've got to master the art of communication. **Without communication, women will become buck wild!** Buck wild, meaning being (uncontrollable or unrestrained) just wild! She will start doing

things that will be unexplainable. Since you don't communicate with her, she will begin to assume what you are not saying.

You must reassure her that she's your elegant work of art and you're going to help her know her value and self-worth. *Remember: your wife is there to increase your value and not decrease your life.*

Men, it is your job to cover your wife so that she doesn't have to feel that she has to cover herself. Women have to feel secure and stable and know that their husbands have their backs. If women don't feel this from their husbands, they will take on an identity that was never meant to be.

If the woman feels that she cannot trust her man, then she will begin to take matters into her own hands and create what she thinks should be. Men, you cannot assume that a woman knows what to do at any given time. You cannot look at her and think that she knows because she's smart, nor because she has her degree. You cannot assume that God is speaking to her. God wants to speak to her through you. Remember, when God came walking through the garden, He did not look for Eve. He asked, "Adam, where are you?" And many women are asking that same question today: where are you, man?

Most men are victims of their ancestors' decisions and responses. What they say is, "Well, my daddy didn't talk to my mother so I don't have to talk to my wife." It's a cop-out! My hope is that we will wake up and smell the coffee! If it didn't work for your daddy, it's not going to work for you. It's time out for blaming someone else for your shortcomings and start being responsible for your own decisions.

It is time to break that vicious cycle. Don't pass on to your sons how not to communicate with their future wives. You may ask, how am I doing that? Easy, by what you do with their mother in front of them. They are receiving hands-on training by watching you at home.

It is time for the real men to take responsibility and not pass the bucks to their wives. *When the following questions are asked,*

What do you want to do?
What bill do you want to pay?
Where do you want to go?

Stop saying

> Whatever you want to do,
> Whatever bill you want to pay,
> Wherever you want to go.

Tell the woman what you want to do! She's waiting for you to make the decision! Provided that she loves God, she is going to honor you with no problem. She will honor your request because she trusts the God in you. *She needs you to lead her, not follow her!*

When there's a lack of leadership, there will be a lack of followership. When the leadership is in its rightful place, followership will fall right in place. Leadership has to communicate with the followership, what's the plan. Once the plan has been communicated and acted upon, then things will start lining up, right in its rightful place.

> *But I would have you know, that the head of every man is Christ; and the head of the woman is the man; and the head of Christ is God.* (1 Cor. 11:3)

> *For the husband is the head of the wife, even as Christ is the head of the church: and he is the saviour of the body.* (Eph. 5:23)

Do not get scared of the word "head." All this is saying is that the man is the responsible party of the household. That means when something is going lacking within the household, it's the man's fault. You may say, how is that the man's fault? Because God ordained for the man to lead his family and guide them in the right direction, to bring glory to the Lord. *What's on the head flows down to the body.*

In a recent survey, they said that more people are getting a divorce in the Christian homes than in the secular world. It should not be so! *What is the number one thing that people are getting a divorce over?* Lack of leadership and communication. Men, you have to open your mouth even if you are not accustomed to speaking to your wife.

You must tell your wife what God has said and carry out the vision for your family.

A God-Follower

You have got to get pass your pride or what Daddy did or did not do and take a stand. Tell your wife what God said. Be a God-follower! *She's been engineered to follow a God-follower.* Show her what you all will do together on behalf of God. Take the lead! Take the lead! Take the lead! In other words, take your pants back! Take them back! Take them back and put them on and be the Man of God that God wants you to be!

I was once told a story that there were two lines to heaven, one for the dominant husband and one for the passive husband. The passive husband line was so long until it was out of sight. There was only one man in the dominant husband line. Everybody was wondering why this man was in the line by himself. He was small and timid and appeared to be anything but a dominant husband. When the angel inquired to why he was in the line, he said, "Well, my wife told me to stand here." (Laugh)

Men, you don't need another Momma, you need a wife. You don't need a woman to tell you everything to do; you have to be led by the Lord. *Hear from God! God said, "My sheep hear my voice and the voice of a stranger, they will not hear"* (John 10:4–5).

I heard another story about two men who were talking and one man said, "I got a poodle for my wife" and the other man said, "I wish I could trade my wife in for something like that." Don't trade your wife in for a poodle, just lead her.

In the book of Genesis, the choice that Eve made was the downfall of man. Adam let his wife make the decision alone without his input. Even after she had bitten the forbidden fruit, Adam still did not step in and advise his wife about what God had said. He followed her lead and took a bite himself. He knew it was wrong, but he allowed her to eat of it first and then she passed it on to him and he ate of it as well.

Passing It On

For centuries, women have been passing to their men the decisions they want to be made. Eve bit into the fruit, and she gave it to her husband. We can always ask—what should have Adam done in this situation? Well, first of all, he could have told her to put the fruit down or throw it away. Throw it as far away from them as she could or he could have taken it himself and thrown it away. Secondly, he could have repented and asked God to forgive them. Yes, I say them because God left the responsibility with the man. Thirdly, he could have called a fast and said to Eve, "Let's fast and pray that God will pardon us." But what did he do? He gave in without a fight!

Stop Running and Hiding from Your Responsibility

He ran and hid as if God could not see them. God sees everything that goes on, and it is now time for men everywhere to stop hiding and start standing up and taking responsibility.

How many times have men had a vision for their families? And the wife says, "I'm not doing it." And you say, "OK!" Instead of standing up and being the Man of God that God wants you to be, you give in to her rebellion. Remember, rebellion is like witchcraft, and you do not want to be partakers of another man's sins!

Do we have any more Jobs in the house today? Let's examine Job's situation:

> *Again there was a day when the sons of God came to present themselves before the LORD, and Satan came also among them to present himself before the LORD. And the LORD said unto Satan, From whence comest thou? And Satan answered the LORD, and said, From going to and fro in the earth, and from walking up and down in it. And the LORD said unto Satan, Hast thou considered my servant Job, that there is none like him in the*

earth, a perfect and an upright man, one that feareth God, and escheweth evil? and still he holdeth fast his integrity, although thou movedst me against him, to destroy him without cause. And Satan answered the LORD, and said, Skin for skin, yea, all that a man hath will he give for his life. But put forth thine hand now, and touch his bone and his flesh, and he will curse thee to thy face. And the LORD said unto Satan, Behold, he is in thine hand; but save his life. So went Satan forth from the presence of the LORD, and smote Job with sore boils from the sole of his foot unto his crown. And he took him a potsherd to scrape himself withal; and he sat down among the ashes. Then said his wife unto him, Dost thou still retain thine integrity? curse God, and die. **But he said unto her, Thou speakest as one of the FOOLISH women speaketh.** *What? shall we receive good at the hand of* God, and shall we not receive evil? In all this did not Job sin with his lips. (Job 2:1–10)

Do You Still Retain Your Integrity?

In Job chapter 2 verse 9, his wife asked him the question, "Do you still retain your integrity after all this?" You may ask what is integrity. It is the quality of being honest and having strong moral principles, moral uprightness. All women need men like Job with integrity. Integrity is a must for any relationship. Job remained stead-fast with his wife. Without integrity, everything else will crumble. We must have integrity in our walk with God and others. We must believe that with integrity, we know that you will be or become the man that God intended for you to become.

Hear what the Word of the Lord has to say about *integrity*:

*And if thou wilt walk before me, as David thy father walked, in **integrity** of heart, and in uprightness, to do according to all that I have commanded thee, and wilt keep my statutes and my judgments: Then I will establish the throne of thy kingdom upon Israel for ever, as I promised to David thy father, saying, There shall not fail thee a man upon the throne of Israel.* (1 Kings 9:4–5)

*God forbid that I should justify you: till I die I will not remove mine **integrity** from me.* (Job 27:5)

*Let me be weighed in an even balance that God may know mine **integrity**.* (Job 31:6)

*The LORD shall judge the people: judge me, O LORD, according to my righteousness, and according to mine **integrity** that is in me.* (Ps. 7:8)

*Let **integrity** and uprightness preserve me; for I wait on thee.* (Ps. 25:21)

*Judge me, O LORD; for I have walked in mine **integrity**: I have trusted also in the LORD; therefore I shall not slide.* (Ps. 26:1)

*But as for me, I will walk in mine **integrity**: redeem me, and be merciful unto me.* (Ps. 26:11)

*And as for me, thou upholdest me in mine **integrity**, and settest me before thy face for ever.* (Ps. 41:12)

*So he fed them according to the **integrity** of his heart; and guided them by the skillfulness of his hands.* (Ps. 78:72)

*The **integrity** of the upright shall guide them: but the perverseness of transgressors shall destroy them.* (Prov. 11:3)

*Better is the poor that walketh in his **integrity**, than he that is perverse in his lips, and is a fool.* (Prov. 19:1)

*The just man walketh in his **integrity**: his children are blessed after him.* (Prov. 20:7)

Women of God, while Satan is attacking your man, you need to be praying and supporting him and finding ways to be the best teammate that you can be. Stop talking *foolish* and start opening your mouth with wisdom. Wisdom can only come from spending time with God in prayer and His Word.

Chapter Two

Make an Impact

Start Impacting and Stop Impressing

Men, stop trying to impress the boys; instead you are here to impact the lives of your wife and children. Impact in such a way that she benefits from your decision to serve God. Your influence should help shape your wife's life for the better. This is why it is very important to receive the proper training, shaping, and teaching because how you've been shaped is exactly how you will shape another. Your active modifications will make and shape her into the Godly woman she's to be, and it will be reciprocated. *How you impact her will impact you!* When you impact your wife, you will stand back and see what your impact has done for her life. Wow!

Don't Allow Your Wife to be "Buck Wild!"

As I said before, you cannot allow your wife to be "buck wild." She will tear your house down with you in it!

> *Every wise woman buildeth her house: but the **fool-***
> ***ish** plucketh it down with her hands.* (Prov. 14:1)

According to the scriptures, God made the man the head. When we look at the human body, the brain is located at the top of the body. The brain is where decisions are made. Yes, the body sends signals to the brain. And just like the body sends signals to the brain, wives send signals to their husbands whether good or bad. If someone is flirting with the wife, she sends signals. If someone is hurting the wife, she sends signals. The husband then makes a decision from the signal that he receives and make a decision. Just like the brain makes the ultimate decision for the body, so is the husband responsible for most of the decisions made in the home because he's hearing from God or he should be hearing from God.

Men, when decisions are made, you can't be wishy-washy on your decisions. Make a decision and stand on it! At times, you will not be popular making a stand. Whether you are liked or not, whether you are popular or not, stand and watch God move on your behalf. It may or may not be the best choice, but God will bless if you have a habit of following Him. I'm not saying that the wife does not have a voice, but the final decision should rest upon the shoulders of the husband. Your wives are here to help and support the vision that God has given you (the man) for the family.

One Flesh

The woman is the receiver of everything that proceedeth out of the man. Every time a man and a woman come together, his seed is planted in her whether it is a baby or whether it is a spirit. Every time you come together, there is a release! Every time you deposit a seed into the woman of your life, it will grow and multiply. Men, you should always want to plant good seed so that your harvest will grow to bless you.

Men, be careful not to let your wife bring forth anger, bitterness, generational curses, or some other type of spirit that is not of God. Must I tell you again? It will grow and multiply! Most men act like they do not know what is happening when in reality they impreg-

nated the woman with the baby or a spirit, which she received from him. *Whatever it is inside the woman is a testimony either for the man or against the man.*

Men, if you see a woman act out in a certain way, it should be natural for you to look at yourself because most of the time, she takes on your spirit.

I know some people say, "Well, I am my own person and she's her own person." But the Bible says the following:

> *Therefore shall a man leave his father and his mother, and shall cleave unto his wife: and they shall be* **one flesh**. (Gen. 2:24)

> *And said, For this cause shall a man leave father and mother, and shall cleave to his wife: and they twain shall be* **one flesh**? (Matt. 19:5)

> *Wherefore they are no more twain, but* **one flesh**. *What therefore God hath joined together, let not man put asunder.* (Matt. 19:6)

> *And they twain shall be* **one flesh**: *so then they are no more twain, but* **one flesh**. (Mark 10:8)

> *For this cause shall a man leave his father and mother, and shall be joined unto his wife, and they two shall be* **one flesh**. (Mark 10:8)

You are one! And whatever you deposit into her, she's going to bring that forth, multiplied.

Created Order

God has order. God has a created order. God has a divine hierarchy. The order of things has been set from the top. *The Word of*

God is our model that we should follow. Look at what 1 Corinthians has to say:

> *But I would have you know, that the head of every man is Christ; and the head of the woman is the man; and the head of Christ is God.* (1 Cor. 11:3)

The body, which is the church, can expect Christ to take care of it. And so should the wife expect her husband to take care of her. Head is equivalent to being responsible, not being harsh or domineering. The woman is to become subject to her head because he's responsible for everything that happens to his household. *Christ is subject to God, Man is subject to Christ, and Woman is subject to Man.*

We should respond to anything that we are under as far as headship in a proper way. Men, your head is Christ. You should submit (bring under) yourself to Christ, not your wife. Wait, hold it, before you come unglued—"well, you know my husband don't have good sense." I'm talking about Godly men, God-fearing, walking upright before God. Of course, the truth is, all mankind are under Christ, but to be more specific, I'm talking about the men who love the Lord and are sold out to God with all their heart, mind, soul, might, and strength. Everything!

Women, when you join yourself to a Man of God, God told you to bring yourself under his leadership and authority. Somewhere and somehow in our society we have missed it. The society has infiltrated the churches, our homes, we are out of place as a people.

The roles have switched in many cases—men are quitting their jobs and the women are becoming the sole breadwinner, and seemingly everybody is all right with this. Hold up! Hold up! (This is personal.) It is not my responsibility to take care of a man! He has the responsibility to take care of me! The only way a woman should take care of the household is in the event something medically has happened that the husband can't work. Also, it may be that both husband and wife have agreed for the wife to work while the husband is pursuing a degree or trade for the betterment of the family.

Let me give you some wise counsel: please do not marry a man that does not have a vision or a job for those who are single! And if

he does have a vision and a job, make sure it is enough to carry you all in the event that you (the woman) are not able to work due to pregnancy, health issues, or some kind of emergency. In other words, have a plan A, B, and C.

He should be able to take care of you if you want to work or if you do not want to work. *If the wife brings home an income, it should be added gravy. It is the added blessings that causes overflow.* Men, you are not to depend on your wives' income. If you have a problem with that, take it up with God because God designed it to be that way. Go get some education and take care of your family. God demands it, and it is a must!

I was a homemaker or a domestic engineer (for you technical folks) for twelve years, and I loved it. My husband did a great job caring for the household until we decided that it was time for me to work. Now, I am enjoying educating children because of the calling that God called me to a long time ago. I am walking and abiding in my calling. God gave me a calling that is not conflicting with my husband's calling. We work so well together, and there is no competition with each other's vision. As a matter of fact, they complement each other.

I am a prime example of what God can do with a woman who hears from God and wait on His timing. Waiting on God and respecting your husband in the waiting time will bring God on the scene with His blessings. When we do it God's way, we get God's results.

We are now receiving the overflow of God's blessings upon us. The goodness of the Lord and the favor of the Lord is resting on us. His blessings are overtaking us, and we love it! It's an awesome feeling being in the Will of God.

I know the Bible says to make your calling and election sure, but that does not mean your calling should cause any confusion between you and your husband. Remember, husbands and wives, your first ministry is HOME. What you do and what you do not do should not cause a disturbance in your relationship. God will never give a vision to the wife or the husband that will cause a division in the household. God is not the author of confusion. You are a team,

and no kingdom divided against itself shall prosper. Whatever you do, do kingdom together!

Look at Ephesians 5:

> *For the husband is the head of the wife, even as Christ is the head of the church: and **he is the saviour of the body**. Therefore as the church is subject unto Christ, so let the wives be to their own husbands in everything.* (Eph. 5:23–24)

We cannot get away from this! The Word of God takes precedence over all other advice, opinions, feelings, and instructions.

Let's look at some more:

> *Husbands, love your wives, even as Christ also loved the church, and **gave himself for it**; That he might **sanctify and cleanse** it with the washing of water by the word, That he might **present it to himself** a glorious church, not having spot, or wrinkle, or any such thing; but that it should be holy and without blemish. **So ought men to love their wives as their own bodies. He that loveth his wife loveth himself.** For no man ever yet hated his own flesh; but nourisheth and cherisheth it, even as the Lord the church: For we are members of his body, of his flesh, and of his bones. For this cause shall a man leave his father and mother, and shall be joined unto his wife, and they two shall be **one flesh.*** (Eph. 5:25–31)

No Praise in the House

Another reason why women act *foolish* is because of *lack of praise in the house.*

*Her children arise up, and call her blessed; her hus-
band also, and he praiseth her.* (Prov. 31:28)

Negative comments will never build anything. These are some of the comments I've heard that many women receive across the world:

"You are too fat."
"You are too bossy."
"You are too aggressive."
"You can't cook."
"You are ugly."
"You are just like your mother."
"You are just stupid."
"You can't learn anything."
"Why aren't you like so-and-so?"

Praise will cause your wife to soar by leaps and bounds. Praise must be in the house more because a woman thrives off praises. The more you praise a woman, the more you receive from her. My husband practices this over and over again. Hallelujah! The more my husband calls me beautiful, the more beautiful I become and the more beautiful I feel. Compliments can go a long way and cause your marriage to soar beyond measure. Build your wife up and she will build you up, and you both will grow together. Women glide and thrive when they know that their men notice them, love them, cherish them, and think they are the best thing since sliced bread.

Even though she's not perfect, you can sculpture her into perfection. Never say she's nothing. You will be surprised what someone else can do with your so-called junk. Don't ever forget why God put women here on this earth. They are here to help man fulfill their call and assignment for God. *When men fulfill their role, the woman's role will almost be guaranteed.*

All women want praise. It's not just your wife, but every woman need it. She needs affirmation, affection, and acceptance from her husband. When a woman get this from her husband, his stock goes up, and the dividends are out of this world. His investment will be

well worth it. Also, remember, women, your man needs to know that you think the world of him as well too. In other words, *men like compliments too*!

Women are here on a divine assignment just like the men. We are here to be a helpmate and not a hellmate. Men have their role, and women have their role. The two shall become one, not just sexually, but in everything as well. A spiritual connection starts to take place when both husbands and wives start walking and talking in the ways of God. How can two walk except they be agreed? (Amos 3:3). You both value the same things of God, and you both want to do things that will make God smile on your relationship. Your connection with God will become so tight that Satan will always have to strategize on how he can penetrate your marriage wall. Your marriage will become solid as a rock. No weapon formed against the marriage shall prosper! Do not give or leave room for Satan's plans to prosper against your marriage; walk in agreement with one another.

Chapter Three

The Power of Compliments

The latest statistics show that more men cheat than women. Sad to announce that more and more women are cheating on their husbands due to lack of care and concern. Many women do not set out to cheat for the most part, but many find themselves cheating because for one, they are trying to get back at their husband who have cheated on them. Another reason is because their husbands make them feel less attractive and unappreciated.

The late Gary Smalley said, "Many women are engaged in affairs because the man that they are engaged with in the affair—he makes them feels like a woman. He compliments her." He tells her that she's beautiful. He tells her that she's wonderful. He tells her that she's sexy. He tells her that she is everything that a man needs. He is appealing to her mind, which is the woman's greatest sex organ. She is drawn to the compliments. I'm not saying that he or she is right for entering into an extramarital affair, but I am saying that men should learn from the action of the compliments that are being given. By no means am I endorsing the sin, but I'm letting you know how women strive when a man gives a compliment about her—she's drawn to it.

She will continue to come back day after day just to receive a compliment because she's moved by the words that are being spoken. She will fix her hair twenty different ways just to get a compliment twenty different times. If you are a man and you are reading this

book, I'm trying to help you see what women need. They need compliments daily!

Don't live in the house and never give a compliment to your wife. She will read it as you don't care—and guess what, she won't care. Women come alive when you as her husband pay attention to details about her. I must say that women look forward to buying something new or doing something new, just so her man will give her compliments.

Men, you don't understand how important it is to give compliments to your wives. After some time has gone by in the relationship, many women feel that they have to compete with other women to get their husband's attention because America is a highly sexual country. Time brings about a change, and we as women need to know that we are still attractive to the man that we will spend the rest of our lives with.

For those of us who have had babies, our bodies have gone through a major transformation, and things don't look the same for most of us. We have put on a little weight and have a little pouch (stomach) for the most part. Some may even have stretch marks that they didn't have any control of. Men, sometimes I don't think you understand that our bodies brought forth a BABY!

Men, you will never know the trauma that our bodies experience bringing forth a baby. Not trying to make any excuses because I do believe that we as women must try to do all we can to keep our bodies up and healthy. Men, you should thank God for your wife carrying your seed and bringing forth life.

Men, you shouldn't ever compare your wife with another woman; no two are made the same. We know that men are stimulated by what they see, but men must know that it's not all about the body of a woman, but her spirit. Hollywood is a joke and full of the fake and the phony. It's a joke and not real. Stop putting so much pressure on your wife to look like Hollywood. If we had our way, our bodies would be flawless, but that's not the case.

It is nerve-racking when men can give someone else a compliment and not give your own wife a compliment, knowing that she's considered as your Good Thing. If you can't say anything good about

yours, please do all us a favor, and don't say anything about someone else's. It's a sad frog that don't praise his own pond!

How's Your Teaching and Instructing?

Learn how to build your wife up! When you build her up, she will build you up. Again, this is why Eve messed things up—because Adam would not talk to her, and give her the instructions that God gave him. He didn't give her the time that she needed. All he had to do is sit down and teach her what God said to do. Adam did not tell her, teach her, or show her, what God was expecting from the both of them.

Now I know that men are saying what if I did tell her, teach her, and show her, what God is expecting. We do realize that there are rebellious women out there that want to do their own things and think that they are in charge. Let me encourage you women not to let the Jezebel spirit operate in you. We can't take matters into our own hands and do what we want to do outside of God's Will. This is not the Will of God that we take charge and take our husbands place. It doesn't matter if you are more gifted, talented, or smarter. God still expects for you to follow His plan and let your husband lead.

Husbands Carry the Blessing

If I took a survey right now and ask how many men lead their wives in prayer, the numbers would be very slim. As the spiritual leader, you have to be the first partaker. Not saying that you will pray first all the time, but most of the time you should take the lead. Men, you carry the blessings! What you speak forth and proclaim should come to pass. Don't wait on your wife to pray; you take the initiative and lead and stop putting it off on her. Stop pushing her out in front; you lead the way!

Prayer is essential in your marriage. It is a must for every relationship. We must hear from God daily, and He must hear from us. Praying together helps you to stay together!

Even if you do not understand everything that's going on, cry out to God and ask Him to bless and help you in your marriage. You should ask the Lord to teach you as the man how to love and relate to your wife. You should say, "God, teach me how to empower her, enhance her, and enlighten her. How to speak over her life and bring the best out of her and not the worst."

Your wife is counting on you as her husband to lead the way because you have been equipped to lead by God. She will love and respect you even more for this.

Nine times out of ten, your wife is already praying, fasting, and reading her Word. The wife is doing everything she knows in order to stand by her man. You as the man need to get in the game, step up to the plate, and hit the ball.

Men, it is essential that you take the lead since you are the head.
Lead the prayer.
Lead the fast.
Lead the Bible study.
Lead the family meetings
Lead in being faithful to God.
Lead in being committed to God.
Lead in being obedient to God.
Lead in being an example to God.
Lead in giving of your time.
Lead in giving of your love to your family.
Lead in giving of your talents for the Glory of God.
Lead in giving of your tithes and offerings.

Give Needed Attention

Men, *put in your woman what God has put in you*! Pour it out on her and give her that attention that she needs. If you don't give her that attention, she's going to get it some other way.

There are many ways women try to get attention:
They put on sexy clothes.
They put on low-cut blouses
They put on excessive makeup.
They wear real tight clothes.
They change their walk and talk.
They become flirtatious.
They do all this just to get men to look at them when all her husband has to do is compliment her for who she is to him.

A Daughter's Need

How many fathers have taken their daughters and given them a big hug and told them that they look absolutely gorgeous? Daddy, if you don't do it, some little Joe Blow is going to come and tell your daughter what you refuse to tell her. By this time, I hope it is not too late to speak into her life. Don't let some knucklehead sweep your daughter off her feet with little words when you could have been the first one.

Compliments are proven and tested when men have daughters. When our daughter was little, after she got dressed, I told her that she looks great—but she would still go over to her father and seek for his approval. If Daddy said she looked pretty, then she was fine.

When my daughter heard her father giving me compliments, she would want to hear the same thing from him. Many times my husband would stroll through the house and say, "How's the most beautifulest woman in the universe?" Before I can answer, my daughter (Mira) and or my niece (Melanie) would answer, "I'm doing just fine!" My daughter used to sit on her father's lap and kiss all over his face. She loved the attention that she would get from her father. Until this day, they are very close and still have little pet names for each other.

My daughter would watch everything, when she was a little girl. She was watching a local pastor and wife get out of the car, and she stated that he must not love his wife like Daddy loves Mommy. I

asked her, why did she say that? She said that he did not come around and open the door for his wife like Daddy does for Mommy. He did not help his wife up the steps. What kind of man is he?

So when her husband came around, that's what she expected of him. She would not settle for less. Your daughters are so precious, and they need you. *I challenge you to love on your daughters.* So when she meets the world, she will be choosy. She won't have to settle for a worldly man; she can choose a Man of God. A man that will love her for her because He loves God!

My daughter would rather ride with her Daddy than ride with me. If we meet up anywhere and she was riding with me, she would jump out of the car and get into the car with her Dad. When Daddy pulls up in the driveway from work, she'd be shouting, "Daddy's home! Daddy's home!" As she began to celebrate Daddy's arrival, I began to celebrate too. If she gets that excited, I would get excited too.

Daughters need attention from their Dad. Don't let them go lacking. It saddens my heart to see nine-, ten-, and eleven-year-old girls get pregnant because there is no father in their lives. Can you imagine—nine-, ten-, and eleven-year-old girls having babies? By the time they reach the age of twenty-two, they have four, five, and six babies before they are married from different men. All their babies have different fathers. *Where are you, Daddy?* Where are you, Adam? You need to give attention to your daughters, set up time for dating and teaching them about men in general.

A Son's Training

Fathers, whether you know it or not, you are training your son. Yes, as you interact with his mother, know that he's watching you to know what to do and what not to do. You are training him to be God's son ready to take on the responsibility for God's daughter.

Father, your sons need training too! Show and teach them how to love God and love their wife as they see you in action. Let your sons see you praying, and studying the Word of God. Let them see

you loving on their mother, treating her as the weaker vessel and being kind and gentle with their mother. Men, never let your sons see you treat their mother in a harsh way. Be kindhearted and have patience with your wife.

Never disrespect or say negative things in front of your children or anybody about their mother. Always show the utmost respect regardless of the situation. Let your sons know that their mother is number one in your life (of course, God first), and nothing or nobody will hurt her while in your care. Train your sons and teach them how to be a Man of God and how they should always treat women who would become a part of their life. Tell your sons, "I want you to treat your wife just like I treat your mother or better."

Mothers, you are there too to help your sons learn how to love God and choose a wife. In Proverbs 31, Lemuel's mother gave him sound advice about how a virtuous king should find a virtuous wife. She gave him details about the attributes of a virtuous woman and how to find the ideal woman for a wife.

Most guys try to find someone like their mother so I pray that you as a Woman of God is being an example of what a virtuous woman looks like. Respect their father! When the son sees how a man is supposed to love his wife and the wife responds to that love, that is one of the greatest gifts you can ever give your sons or daughters.

Make Time, Take Time

Make time and take time for your family. Make time and take time for your wife. Even though we are in a hurry-hurry, rush-rush society, you must slow it down and spend time with your wife and family. Tell your wife, "Tonight, put on your finest because we are getting out of this house so I can spend time with you and you with me." *Dinner time is intimate time.* Sit across from each other so that you can gaze into each other's eyes and start talking sweet to each other. You will find out that the fire will come back and there will be a new love for each other that will be generated from the Lord. You will be loving one other like when you first met each other.

Husbands and wives must spend more time coming together sexually. Recent studies have shown that husbands and wives make love less than ever before. Some studies have shown that couples come together as little as four times a year or they just become sexless. Sexless! My husband would have a fit and so would I. Inmate time for us is a must! I must say the older we get, the better it becomes. Wow!

What is going on with married couples? Sex is one of the main reasons that you get married. (It's better to marry than to burn.) Researchers say that having lots of sex is healthy for all marriages. They found that a couple that come together often (at least two to four times a week) are happier and live longer. God ordained sex, and it is great in the confinement of marriage only.

It's so sad to hear couples say they haven't made love in three months, six months, a year, or years. We need to take out what's in the single people and put it in the married people. The scripture says that the two shall become one. How can you become one if you don't come together? Now we find that many couples do not enjoy making love or enjoy each other like God intended. Many couples do not even flirt with each other, or tease, or touch, or just have fun being in each other's presence. This is a trick of the enemy (the devil) to make husbands and wives become enemies toward each other. We are supposed to be two who will become one. How are we going to fight off the devil when we are fighting each other?

If there is something medically wrong, go to the doctor and find out if there's something healthy out there that can help you fire things back up and keep it burning. You are here to please each other. Your body do not belong to you and vice versa.

First Corinthians 7:4 says, "The wife does not have authority over her own body but yields it to her husband. In the same way the husband does not have authority over his own body but yields it to his wife."

Also, in that same chapter verse number 5, it says, "Defraud ye not one the other, except it be by consent for a season, that ye may give yourselves unto prayer, and may be together again, that Satan tempt you not because of your incontinency (unable to restrain your flesh)."

It is so important for husbands to give of themselves and wives give of themselves. Learn how to love and romance each other and stop being so stale, dry, and boring. My husband and I are still madly in love with one another as if we just met each other. We are so determine to keep the fire lit until we go home to be with the Lord.

I ask if each couple will evaluate their relationship and make a commitment that they will start coming together at least 2-times a week, if possible. Make time and set aside time for your honey each week; you'll be glad that you did.

Never Make Negative or Smart Remarks about Your Wife

The worst thing that a man can ever do is make a negative or smart comment about his wife, his mother, or his daughter in front of another woman about them. There will be trouble in the house! She will make a *foolish* choice to pay you back. Remember, men, words hurt and leave scars. Men, you have to be very mindful and wise of the words that you speak to your wife. Words build or tear down. You must speak those things that be not as though they were. You have to be intentional and think your words through before they are ever spoken. Be quick to listen and slow to speak. Invest your time and words to produce what you want or what you want your wife to become.

Testimony time: I was a very insecure person and felt insignificant at times. My husband would speak and invest his words into me daily. As the years went by, I gradually saw my confidence level climb higher and higher each year. That's why this book took me so long to write because I didn't think that this book would be useful in anyone's life. As I began to write and research how many women are suffering in their marriage, I quickly realized that someone would be blessed by what the Lord placed in my heart.

The words that he spoke over my life has caused me to become a very confident person. I know who I am, and I know whose I am. I'm forever grateful to God for sending an awesome Man of God for

me to have in my life. He has helped mold and shape me into the woman that I am today.

Men, it is very critical and vital that you speak words of life into your honey's life on a day-to-day basis. By speaking words of life into your honey's life, you will be able to see a drastic change in her life, and this will be a benefit to you.

Missing in Action (MIA)

Another reason why women will act *foolish* is when they as wives can't find their men anywhere. Men that are married should find themselves spending more time with their wives instead of the boys. Men, your wives need you at home; they need you to help them grow spiritually. The wife needs help with the children, with the bills, and with the chores (especially if she works outside the home). Even when you are home, you are not home, meaning there is no involvement with you. You become more of a burden than a blessing.

Women do not need a child for a husband; they need a husband and a man that will give them stability and security. The wife needs help with the children you gave her. It's not just her responsibility to nurture and care for the baby; the baby is yours too! You had a hand in creating the little human being as well; she couldn't produce the baby by herself.

Men must stop being MIA! Your wife is not your mother, so stop acting like she's going to take care of everything including you. *She needs you to be her partner, not her problem.* Do not leave it to your wife to make most of the decisions for the household when you are supposed to be right there with her. Remember, you are Partners In Christ (PIC). God placed you there to be strong and stabilize the home so that your wife will not be stressed out about life.

I read something on social media that said "husbands stress their wives more than their children do," and many women agreed with that statement. That should not be so; the husband should be a stress reliever and not a stress maker. When a wife is stressed out, it's a pretty good indicator that she's going to make some bad decisions.

Sometimes being stressful will make women make *foolish* choices that will cause the whole household to suffer.

Men, you must be caring, loving, concerned husbands; if not, you are going to turn a great marriage into a disgusting marriage. You must go the extra mile for your wife. Stop thinking average and think above average for you and your wife. God, wants you to have a marital bliss!

Whatever you want your wife to be, you will have to put it in her. If you want her to be submissive, then you are going to have to submit yourself to Christ. You are going to have to be sensitive to the Spirit of Christ or when the Lord is trying to tell you something—it would be wise if you be first partaker of what is required. If you want her to be sensitive to you, you must first be sensitive to her.

Know Why Your Wife Is Here

Women are not in the same category as a bird, alligator, or any farm animal. Woman came forth out of the rib of man, a place that is dear and close to his side. God took woman out of man's side, and He formed and fashioned her to help man. She's a part of you, so never bring home a negative response to your wife to tear her down. Because if you are tearing her down, you are tearing yourself down.

Men, you can say you have it all together. But if I took a secret poll from the women, it would be altogether different about your marriage, your situation, your family, and your personal business. Many responses would come back saying, "I'm angry!" "I'm bitter!" "I'm upset!" "I want out of this marriage." Many women feel like they married the wrong man, and this is not what they signed up for.

Do you know if your wife is happy being married to you? Ask her!

Are you happy with me?

Are you secure with me?

Are you in love with me?

Are you satisfied with me?

Are you living the God kind of life with me?

Are you being fulfilled with me?

Are you progressing with me?

Don't assume that everything is all right just because you are bringing home the check. Many have said and will say, "She's all right." And then twenty, thirty, and forty years down the road you find out that she never felt complete being your wife. Now since all the kids are gone, she would say, "I'm going too." Many would be saying, "I have had enough, my kids are grown, this is it, and I'm out of here too."

When you are torn, beaten down, talked down, worn down, you feel you have nothing else to give. She's ripped into pieces because of what you have done to her throughout the years.

You may ask, what have I done? That's just it; you have not done a good job in nurturing and caring for her as your wife. Speaking into your wife's life and causing her to open up and blossom like the flower she is, is your job as a Man of God.

Chapter Four

Created Equal

I'm not here to badger men or to create a perfect man. I'm just trying to get something to stick in your mind on how to be a successful Man of God, how a man through this teaching can help him to become all God wants him to be. Also, to be a model for our society and show the world how we as believers can have a great marriage and home life through Jesus Christ.

Well, where do we go from here? We have learned that a woman needs communication, praise, attention and let's talk a little about equality. Let's go to the Word of God and see what God has to say about this.

> *And the rib, which the Lord God had taken from man, made he a woman, and brought her unto the man. (Gen. 2:22–24)*

He built up and made the rib into a woman. The rib meaning that it came out of his side so that he would protect her and comfort her from any and everything. God didn't take her from the head to be his superior. Neither is the man to use his headship to dominate. Men who are domineering, it shows that you don't really love your wife and you are insecure inside. You think that by making her feel like she is a child you got some kind of power. You don't have power, you have a problem. God needs to deliver you so that you will know

that she is God's daughter, not yours. In 1 Peter 3:7, it says to honor her as the weaker vessel. Every time you say something harsh or be too stern with her, you mess her up mentally. She's not from your feet to be inferior to you, but God took her from your side to be equal with you.

Let me explain about being equal: *We are equal because we both are of the human race, but the man has a role and the woman has a role.* This is all through the Word of God. Man has a role as the head, and the woman has the role of being under the head as the helper. I know that there are many women who disagree with me, but I'm just speaking the Word of God. I know we say a woman can do whatever a man can do, and this is a true statement according to our society, but that's not what God has ordained for His children. He gave specific instructions for us to go by. Yes, all can be saved, but not all can do specific or certain tasks. If all can do the same thing, *why can't a man give birth to a baby just like a woman cannot have a baby without a man's seed?* So know this, if we cannot do it God's way, then we are headed for disaster doing it the world's way. If you are saved, then whose report are we going to believe?

God put the woman in Adam's care. To protect her and love her. The woman is a part of man because she came out of man (vs 22).

God made her ready for the man, and God gave the bride to Adam. He said, "I will give you someone who is suitable, adapted, well-fitted, and she will compliment you" (Gen. 2:18). God gave away the woman: Who give this woman to be wed, and God said, "I do, Adam take your bride." What He was saying was she is your responsibility for the rest of your life. Not when you feel like everything is going good, but for the rest of your life!

This is a clip from *New Man Magazine*:

> An alarming report finds that Christians are more likely to divorce than those who are non-Christians. A study by the Barna Research Group also reveals that atheists are less likely to end their marriage than born-again believers.

The sobering findings, just released, come from a survey of nearly 4,000 adults. They discovered that 27% percent of born-again Christians are or have previously been divorced—compared to 24% percent of others.

Within the denominations surveyed, Baptists recorded the highest divorce rate, with 29%. Catholics had the lowest with 21%. This is with denominations. Within the Non-Denominational Christians the rate was 34%. The Mormon rate was 24%, while for atheists and agnostics it was 21%.

Approximately 90% of born-again Christians who have ever been divorced experienced a marital breakup since they became Christians. This is a trick of the enemy. More, and more men are not being faithful to their wives. For the most part, this causes women to be unfaithful because men are not faithful as they should be to their wives.

Women act *foolish* when *foolish* things are done to them, like from childhood with the parents or adolescence, if someone had forced themselves on the young woman or either when a husband has forced himself on his wife. Many women come into a relationship already scared; they are emotionally broken down. When abused by someone verbally, physically, or sexually, women will need someone to comfort and push them up and forward, and that someone is man who was created to create.

Many men feel like they don't have to say anything good about their wives because they bring home the check and let her spend it anyway she wants. That's nice, but that's not all what a woman is looking for. Women are more personal than men; they like to be cozy and touchy. We want a relationship along with the paycheck. Normally, she's more enthusiastic about the relationship than the man is because she sees more than just sex, having babies, cooking,

and keeping the house clean. A wife wants to know that her husband is happy with her. Women feel that their marriage should be more than a paycheck, more than a house, and more than things. She wants her man to want her and make her think that he can't imagine life with any one else but her. She does not want to feel that she is in the relationship alone. The wife needs to know and feel that she and her husband have a heart connection together forever.

Women are eager to find out what they need to do to better their marriage; they are the ones that will go to counsel, buy books, CDs, DVDs; but most men think that they don't need all that. For the life of me, I don't know why they think that they are just fine.

What's going on around here? Somebody has to sound the alarm, and God will use me and others to be a mouthpiece.

Your wife is the other half of you (more accurately the better half). When you sleep around on her, you break covenant with your wife and you break covenant with God as well.

> *For on account of a harlot a man is brought to a piece of bread, and the adulteress stalks and snared as with a hook the precious life of a man.* (Prov. 6:26, Amp)

Don't let your wife have to wonder if you are being faithful to her. Let your wife know that she is the best thing that ever happened to you. *She needs to feel secure, in that she's on the top of the list; she's number one and the only one.*

In verse 23, Adam said, "*This creature is now bone of my bone, and flesh of my flesh: she shall be called Woman because she was taken out of me.*" The word *woman* in the Hebrew language is very similar to the word *ish*, which is "man." And the word for "woman" is *ishshah*. She is the other part of man and is to answer to him. God intended man to take the lead; that's why He created the man first and He created woman next. The *man is the aggressor* (God made him that way even physically), and *woman is the responder.*

DR. VERONICA G. BEE

A Woman's Response

A woman will respond to whatever you give out. If she is cold, it's because the man is cold. If she is silly, that's because the man is silly. The list can go on and on. I love to have fun; that's because I have a husband that is full of life and doesn't believe in being dry. Our marriage is full of life, and we love being with each other daily. It's what you make out of life. You can choose to have a happy marriage or a sad marriage.

The man takes the lead, and wherever he leads, the woman will follow, whether for the good or the bad. You have a few exceptions, but *by nature, the woman is a follower.*

> *Even so husband should love their wives as being in a sense their own bodies. He who loves his own wife loves himself.* (Eph. 5:28, Amp)

Men marry having absolutely no idea on how to love their wives. They think, "I can have as much sex as I want, and I can do whatever my freaky self want to do." The bed is undefiled, but what that means is that you are legal to be in the bed together if you are married. It doesn't mean that I can put on my leather suit and take out my whips and knives and do kinky stuff that you see on a porno tape, all to get a sexual high. God told the children of Israel not to adopt the ways of the pagans. Marriage is supposed to be a sacred thing, ordained by God. We should not mimic the world, but we should mimic the Word!

Training is Needed

Isn't it funny how we have training for most of everything we do, except when we go into marriage, we think that we're going to have a successful marriage without training? It takes work, and it takes hard work. We can build million-dollar aircraft, send man to the moon, build sky towers, master our jobs, but when it comes to

making a meaningful relationship with your wives, men clam up and have pitiful excuses: "I don't like to talk, I don't like to hug up with her." "If I give her a compliment, she'll get beside herself." She needs all that and some more to help her be the Woman of God that she needs to be.

Gary Smalley asked five divorced women individually, "If your husband began treating you in a consistently loving manner, would you take him back?" Each one of them replied yes they will. That's because they want a man that care about them more than he cares about himself.

Men and women enter marriage with "storybook" expectations. A storybook marriage is just a fantasy, not reality. Marriage is work, but it's a good work. God will work something out of you that you didn't know was in you; that's what the work is all about.

How many couples receive counseling before marriage? Not many because many feel that they know how to be a husband and how to be a wife. No, we all need counseling and training!

> *Therefore a man shall leave his father and his mother and shall become united and cleave to his wife and the shall become one flesh.* (verse 24)

God ordained marriage. The world is trying to make us think that there's nothing to marriage. It was the first thing instituted by God for the human race. He told the man to leave his mother and be joined to your wife forever. In other words, be responsible, don't live off your father and mother. Stick to your wife like glue, and don't let anything come between you and your wife.

Be a man of God. Love and cherish your wife, talk her up, give her respect, honor and praise her, not only at home, but also out in public. Let her know that you appreciate her for being a godly wife. Do what the Bible say to do and watch how your life spiritually, physically, mentally, and financially grows just by taking heed to the Word of God!

Chapter Five

Romance Is a Must

According to Willard F. Harley, Jr., author of His Needs Her Needs for Parents, "Confusion about **romance** is partly due to the radically different perspective of men and women. Men tend to think of romance one way, and women tend to think of it another way. So when the word is used, men and women have entirely different expectations. Since **romance** is something they share together, it's no surprise that many are confused." (p. 18)

What is a **romantic** relationship?

> *"A romantic relationship consists of two people in love who meet each other's emotional needs for intimacy."* (p. 18)

Romantic Love Is an All-Day Affair

"Some people who are NOT in love think they have a **romantic** relationship because they try to meet each other's intimate emotional needs. Others feel that only love is needed to define a **romantic** relationship. But if you give it a little thought, I think you'll agree with me; people are not in a truly **romantic** relationship unless they are IN love *while* meeting each other's needs for intimacy." (p. 18)

Most men would love to be so enamored with their wife that they can't wait to get home to her. They desire their wives to be their best friend, their lover, and sexual playmate. The average man dreams about having someone this special but never experienced this kind of excitement. Why? Because they never invest the necessary things that it takes to materialize this kind of *romance*.

It's one thing to desire a thing, but it's totally different to do what it takes to make a desire appear. What will it take? It will take a committed life of studying one's wife's desires. See, when you meet her needs, she will meet your needs. She's been programmed to return things better for which she was given. She's engineered to woo and wow her husband given the right goods. She's been created to create better. Loved right by her husband, she will never walk away without leaving an increase.

Romance can excite a wife in such a way that she will perform above and beyond your expectation. To some, this mystery of *romance* is a treasure waiting to be found. Traveling through this maze of marriage as the two explore, there will be some turnarounds and turnabouts until you reach your prize and goals together. It is so much fun to explore and find *romance* that enhance.

What are some of the discoveries to be found in order to experience romance?

- Make her feel needed and appreciated.
- Never criticize her body, face, or anything about her.
- Tell her what you like about her.
- Delight in any new lingerie purchases and when she models them.
- Chase her, continually letting her know you have the hots for her.
- Anytime she makes an extra effort to dress up, go on and on as if she's Miss Universe.
- Don't mention her cellulite.
- Ask her where she wants to go when you eat out.
- Share your food with her in the restaurant.

- Never be ashamed to show your emotions to her.
- Regularly attend church together.
- Take her away for a special weekend.
- Take her on a shopping spree to intimate clothing store—that might end up as your own private fashion show.
- Give her flowers when there's no special occasion.
- Send her a card at least once a week.
- Celebrate her gifts and talents.
- Tell her she's pretty when she's not dressed up and have no makeup.
- Never criticize her in public or in front of the children. Praise in public and correct in private.
- Never gripe about meals she fixes—even if it's a flop and tastes like something from out of space.
- Always make her feel good about her hair, even on a bad hair day.
- Give her foot massages.
- Often join her in the shower.
- Never tell her you wish you'd married someone else.
- Don't be afraid to say "I was wrong" when you were—even when dealing with the children.
- Keep your promises.
- Put a lot of verbal effort into seduction.
- Ask her what her sexual favorites are and repeat them often.
- Don't take a second look at other women.
- Hold and cherish her from time to time without sexual touching.
- Don't sexually pressure her if she's sick.
- Listen to her.
- Simply admire her just the way she is.
- Go by her office or workplace and have lunch with her.
- Arrange for the two of you to take a bath together with candles glowing.
- Take her on a date and don't tell her where you're going.
- Always use words of good taste.
- Consult her on every major decision.

- Automatically take care of things in your area of expertise (such as car and house maintenance) without her having to ask you.
- Always insist that she take the first bite of your ice cream.
- Always insist that she drive the newest vehicle.
- Make it a habit to drop everything and come to her rescue during any crisis.
- Never hit or threaten to hit her with actions or words.
- Pray for her.
- Listen to her dreams and don't make fun of them.
- Share your last piece of pie instead of keeping it all for yourself.
- Rub her back even though you may be tired.
- Let her pick the movie sometimes.
- Don't demand a before-bedtime quickie when she's especially tired; instead, make the time another night and enjoy yourselves more.
- Apologize when you are wrong.
- Keep her laughing so she doesn't take herself too seriously.
- Remind her of God's promises when times are tough.
- Make her feel beautiful even when she doesn't look (or act) like it.

A lot of women act *foolish* because of the lack of romance. My husband always say, "The greatest sex organ on a woman's body is her mind." When a man appeals to a woman's mind, he activates a trigger in her body that receives his transmission. The greatest turn-on for a woman is a man who knows how to move her with words. Your words are a creative force. You can set the atmosphere with your words. Once your words are in the right place, your hands can follow. Follow by the kissing, the blowing, and the caressing. And I'll let you tell the rest of the story.

In *romance*, sweet talk is a must. Sweet talk will allow you to explore and come back for more. A woman loves to be told she's beautiful. She's pretty. She's lovely. She's wonderful. She's gorgeous. She's awesome. She's a blessing.

A lot of men don't like to hear this, but she's your responsibility and you are to please her. *Romance* is synonymous with pleasure. We've all heard the saying, "When Momma is pleased, then everybody is pleased."

She's Your Queen!

Since she's your queen, she should be treated as such.

> *And the king loved Esther more than all the women, and she found favor and kindness with him...so that he set the royal crown on her head and made her **queen**.* (Esther 2:17, NASB)

Before I share with you the ways she should be treated like a queen, let me share with you how not to treat your wife.

How Not to Treat Your Wife:

Do not treat her as a **packed mule** (or a **workhorse**) throwing every responsibility on her until she collapses. You, as the man, can carry the load because of what God put in you.

Do not treat her as a **donkey**—an unintelligent fool that doesn't know anything.

Do not treat her as a **mouse**—squelching her personality; being overbearing; allowing her just to squeak a little once in a while, but not helping her to grow into the person God intended for her to be.

Do not treat her as a **lion**, king of the jungle—bowing to every demand, abdicating your leadership in the home and allowing her to take over and rule the roost; some husbands are completely dominated by their wife as they live as a mouse in their home.

Do not treat her as a **golden retriever** (get this for me; do this for me) rather than as a helpmate provided by God; your wife was not intended to be your slave.

Do not treat her as just one of the **worker bees** rather than as the **Queen Bee** of the masses versus that very special and unique one. She needs active appreciation, "assigning honor to her life."

Key questions that you should ask in order to see the value of your wife:

What value do I place on my wife?
How precious is she to me?
What type of gift did God provide for me?

Value of a Wife

> *An excellent wife, who can find? For her worth is far above jewels.* (Prov. 31:10)

> *How blessed is the man who finds wisdom, And the man who gains understanding. For its profit is better than the profit of silver, And its gain than fine gold.* (Prov. 3:13–14)

> *An excellent wife is the crown of her husband.* (Prov. 12:4)

> *He who finds a wife finds a good thing, and obtains favor from the Lord.* (Prov. 18:22)

> *House and wealth are an inheritance from fathers, But a prudent wife is from the Lord.* (Proverbs 19:14)

When we speak of value, we speak of worth, usefulness, and/ or importance. To me, *foolishness* is when a man does not know the value and worth of what God has given him—his wife. It is the dev-

il's job to devalue, depreciate, underrate, or undervalue a precious gem. Because God made her, she's designed to make things better than its original state. She's given the title "helpmate" because without her, things would not reach its full potential. If her husband is wise, he would value her time, gifts, and talents. And he would count it an honor to be connected to a fine specimen of a woman who will commit herself as a lifelong partner.

The wife's privileged status entitles her to special consideration from her husband:

> *Likewise, ye husbands, dwell with them according to knowledge, giving honour unto the wife, as unto* **the weaker vessel**, *and as being heirs together of the grace of life; that your prayers be not hindered.* (1 Pet. 3:7)

> *In the same way you husbands must live with your wives with the proper understanding that they are* **more delicate than you.** *Treat them with respect, because they also will receive, together with you, God's gift of life. Do this so that nothing will interfere with your prayers.* (1 Pet. 3:7, GNT)

She's to be treated as a queen because she's considered "the weaker vessel." According to my research, the weaker vessel is like unto delicate china. What does one do with delicate china? They put it up on the top shelf or under lock and key for others not to touch or handle. I know within my own home I have a china cabinet specially made for china that my husband and I collected years ago while in Japan. Within our china cabinet are lights that may be turned on to view the detail of the china. As the china is to be seen and not touched, so is a man's wife; she's to be placed in a special place in his heart only for him. She's to be seen by many, but only touched by her husband.

Women are the weaker vessel; they are fragile. They can't take as much as men physically. Therefore, women need more building up than men. They need reassurance, security, and encouragement.

If perhaps someone decides to handle the delicate china and break it, that would be a costly mistake. That's why it's only to be seen and not touched! It's only to be touched or handled by the caretaker.

Likewise, a man's delicate china (his wife) is to be touched or handled by him. This is the reason why he nourishes and cherishes her for the rest of his life.

> So ought men to love their wives as their own bodies. He that loveth his wife loveth himself. For no man ever yet hated his own flesh; but **nourisheth** and **cherisheth** it, even as the Lord the church. (Eph. 5:28–29)

According to the Word of God, *nourish* and *cherish* is related to building up emotionally. Men must have a soft side that he must show to his wife. The husband sets the pace by making the first move and setting the standard. Because of his actions, she receives this nourishment *(to set mind at rest)*, and she gives it back to him. He cultivates, nurtures, and reassures her that he loves her intimately and her alone above all else. Then he cherishes *(appreciated, valued treasure)* her by showing how important she is to him and relishes the ground she walks on! This causes emotional stability because the love is reciprocated.

What a Woman Needs

Men, your delicate china, valued treasure, prized possession, exquisite fortune need the following:

Love

In our society, I believe we have misused and abused the word *love*. Love is a strong word, and it is not to be used haphazardly. Love has been misused for lust. Love has been abused for things we like. You should never love anything that cannot love you back. My prayer is that everyone has a "summa cum laude" relationship. Why a summa cum laude? Well, it is Latin and means "of highest distinction or worthy of highest praise." You can easily see why the Word of God declares that charity (love) is the "summa cum laude" that every believer should possess. Paul, in scripture, mentions hope, faith, and love; but out of the three, he says that love is the highest.

Types of Love

In the Bible, there are four main words used for love:

Storge
Philia
Eros
Agape

Storge—empathy love

Storge (*storgē*, Greek: στοργή) is liking someone through the fondness of familiarity, family members, or people who relate in unpretentious ways that have otherwise found themselves bonded by happenstance. An example is the natural love and affection of a parent for their child. It is described as the most natural, emotive, and widely diffused of loves: natural in that it is present without coercion, emotive because it is the result of fondness due to familiarity; and most widely diffused because it pays the least attention to those characteristics deemed "valuable" or worthy of love and, as a result, is able to transcend most discriminating factors. C. S. Lewis, a

renowned author and theologian, describes it as a dependency-based love, which risks extinction if the needs cease to be met.

Philia—friend love

Philia (philía, Greek: φιλία) is the love between friends as close as brothers and sisters within a family in strength and duration. The friendship is the strong bond existing between people who share common values, interests, or activities. Lewis immediately differentiates friendship love from the other loves. He describes friendship as "the least biological, organic, instinctive, gregarious and necessary... the least natural of loves." Our species does not need friendship in order to reproduce, but to the classical and medieval worlds, it is a higher-level love because it is freely chosen.

Lewis explains that true friendships, like the friendship between David and Jonathan in the Bible, are almost a lost art. He expresses a strong distaste for the way modern society ignores friendship. With the computer and technology era, we can truly see that this kind of friendship is becoming almost extinct. Our world is inundated with social media such as email, text, Facebook, Snapchat, Instagram, and so much more until friendship affection is slowly dying.

Eros—erotic love

Eros (erōs, Greek: ἔρως) for Lewis was love in the sense of "being in love" or "loving" someone, as opposed to the raw sexuality of what he called Venus: the illustration Lewis used was the distinction between "wanting a woman" and wanting one particular woman—something that matched his (classical) view of man as a rational animal, a composite both of reasoning angel and instinctual alley cat.

Eros turns the need pleasure of Venus into the most appreciative of all pleasures, but nevertheless, Lewis warned against the modern tendency for Eros to become a god to people who fully submit themselves to it, a justification for selfishness, even a phallic religion.

After exploring sexual activity and its spiritual significance in both a pagan and a Christian sense, he notes how Eros (or being in love) is in itself an indifferent, neutral force: how "Eros in all his splendor…may urge to evil as well as good."

Agape—unconditional "God" love

Charity (*agápē*, Greek: ἀγάπη) is the love that exists regardless of changing circumstances. Lewis recognizes this selfless love as the greatest of the four loves and sees it as a specifically Christian virtue to achieve. The chapter on the subject focuses on the need to subordinate the other three natural loves—as Lewis puts it, "The natural loves are not self-sufficient"—to the love of God, who is full of charitable love, to prevent what he termed their "demonic" self-aggrandizement.

Love is the key ingredient in a woman not acting *foolish*. I have learned that love isn't love until it is given away. True love gives: "*For God so loved the world, that he **gave** his only begotten Son, that whosoever believeth in him should not perish, but have everlasting life*" (*John 3:16*). By nature, men are givers and women are receivers. Love is always reciprocated. When you give it, it comes back to you many times multiplied. Thus, if you don't want your wife to act *foolish*, love her unconditionally the same way God and His Son (Jesus Christ) loved by giving. Simply put, if you are not giving, you are not loving. No giving, no loving.

Security

> *If you stop sinning and start doing right, you will keep living and be **secure** forever.* (Psalm 37:27)

> *Sin cannot offer **security**! But if you live right, you will be as **secure** as a tree with deep roots.* (Proverbs 12:3)

Infidelity will definitely cause a woman to feel insecure. An extramarital affair is one of the number one causes of destroying or killing a marriage. Unfaithfulness is at the top of the list because it breaks the covenant that was sealed by a husband and wife. *Disloyalty does something to a woman's mind that's beyond explaining.* A woman will give of herself and become vulnerable if she's secure in her relationship. When she's sure of her connection with her husband, she performs at her best in the role that God has given her. She has to be attached in such a way that cause her to be reassured that this relationship is intact and no one is able to break this bond. Many don't know where to find the optimum security in life; therefore, they search endlessly in the wrong places and in the wrong way.

Because of their lack of knowledge or erroneous teaching, most people think that security is found in a person, or in money, or material possessions. You can never find security in these things. *Security is found in knowing what God said about you.* Once one knows who they are and whose they are, they will be totally confident and inspirited in their role and purpose given to them by God. A person that is secure will accept themselves for who they are. It is very essential to say *a woman performs better when she's secure.*

Stability

Many professional counselors have discovered that going to church will two times more cause a relationship to be solid. Also, they have found out that your good attitude toward your spouse causes a marriage to be steady. For a woman to be anchored, she must know that she can count on her husband regardless of what takes place in the marriage. We may not want to face it, but finances plays a big part in a woman's stability. Arguments are inevitable when the money is funny. If you want to see a woman act *foolish*, be void of money.

Conversation

One of the worst treatments is silent treatment. When we confabulate with one another, it brings us closer together. A woman is built to converse. She enjoys heart-to-heart talks with others. A man talking with a woman is a need for her. Notice that I did not say *to* her, but *with* her. "Because males have a leadership mind-set, sometimes their conversations with their wives amount to instructions rather than a give-and-take dialogue." I have discovered that a man says what he thinks and a woman says what she feels. You will find out that by discussing your interests with your wife, it will build a natural bridge of communication between the two of you. "To truly meet her need, you should talk with her at the *feeling* level and not just the knowledge and information level." When conversing with one another, it's very critical that we listen to one another. Anyone can hear the other person talk, but it takes a concerted effort to listen.

My husband often asks me, "Do you want me to listen for you to vent or do you want me to listen to respond?" I understand that is wisdom because most men hear their wives but are not listening to their wives. Listening is a two-way communication transmission. As I give my speech, my husband is listening in a way that he can give it back to me and I know he was listening, not just hearing. In other words, for a conversation to take place, there must be a transmitter and a receiver. Then it reverses; the receiver becomes the transmitter, and the transmitter becomes the receiver. We both know when communication has transpired when understanding is known by the both of us.

Affection

Affection is a woman's need. Affection is part of who she is. "A woman doesn't just want affection—she needs it!" As soon as a man understands this, he will discover that he will have the best sex life ever. Knowing that the male's primary need is sex and understanding that one of his wife's primary needs is affection, he will have the

secret to unlocking her body. When these two interrelated needs are understood and balanced, they will find out that they will avoid a whole lot of conflict within the marriage. If men would *learn the Art of Affection* and not focus totally on their need, they will have uncommon insight on how to have their needs met. This is how it works: when the affection button is pushed and open all day, the sex button will be blinking red (which stands for hot), and things will happen automatically. If you desire the continuous flow of love, affection must precede sexual intimacy. In order for a woman to feel loved and be fulfilled, she needs an environment of affection.

Chapter Six

Starving for Attention

Women who are starving for attention will act *foolish*. Lack of attention will lead to a woman acting *foolish*. Understanding that this is not her normal self, she will become imprudent in her decision making.

Men have to take notice to what his "good thing" is lacking so he can fulfill that void in her life for which she craves. He should study her to the point that he realize something is needed in her life for her edification.

Please give your wife the attention she needs! This will make things better for you.

A woman starving for attention will do things that will create tension within the relationship. She will do the following:

> Speak out of turn
> Be mean-spirited
> Wander off
> Behave unseemly
> Do things unbecoming
> Have improper actions
> Treat others badly
> Disrespect others
> Berate others
> Have a bad attitude
> Display bad conduct

To act *foolish* may not be in your wife's nature; however, because of what she is experiencing, it becomes her perspective. Her perspective becomes her reality. Even though she may be an awesome Woman of God, she compares herself to others believing that what they have is better.

Rejection

Rejection could be the seed of her *foolish* ways. A woman who needs attention does not deal with rejection very well. When one's history is constant rejection, there is an attitude of not caring that's presented. Rejection will cause one to act out of character. Rejection reminds one of past pain. No one wants to be reminded of their past hurts, sufferings, failures, or discomfort. Men, you are her covering and you are assigned to bring hope, healing, and wholeness to your wife regardless of her past hurts.

Neglect

When a woman is mistreated and neglected, she feels deserted. She will act *foolish* and do things not becoming of a precious Woman of God. She is to be attended to as a well-kept home. Her value should appreciate, not depreciate. One of the worst reflections on a man is to see a wife uncared for! This shows what he thinks about his so-called valuable rib. Far too many good women have been neglected and taken for granted, and enough is enough. Men, take your rightful place and refuse to allow your prized possession go another day without your tender loving care. She is engineered to respond to your care—the more you value her by caring for her, the more she will return care back to you in uncountable ways. When a wife is beyond priceless to her husband, she will never be forsaken by him.

Abandonment

The *foolish* actions may occur because of her upbringing. If a woman feel she's been left alone, it could affect her future. Many times it spills over into her adulthood. The feeling of loneliness unless dealt with will plague her for years to come.

When it comes to rejection, neglect, and or abandonment, deliverance in one's life is very much needed. I say deliverance because many times a person that has all these emotions are replete with historical baggage.

Even though we cannot prognosticate a person's future, we can attempt to seek proper counseling that will lead to the freedom of these egregious (outstandingly bad or shocking behavior) emotions.

Now is the time to stop starving your wife for attention and affection! Give her the care and treatment that she deserves. You may keep the refrigerator full, the car running, and the bills paid, yet your wife may be suffering severely for attention and affection.

Here's something to consider: Most affairs start not for sex, but out of a need for attention and affection. Men, if you don't pay attention to your wife, she will find someone else who will give her attention and affection that she needs. She has to have both.

Some men are starving their wives emotionally. Some wives get no positive affirmation. Their husbands always find something to criticize about their cooking, cleaning, and upkeep of the children. If she makes a great meal, all they can say is "Well, that's a first!" No woman wants to hear negativity about her efforts and work constantly.

Many wives are dying on the inside because of lack of attention. Men, *stop* starving your wives! Nourish her! Cherish her! Give her what she needs to thrive and stay alive! Some wives are deprived of their spiritual growth because their husband is not in his rightful place. Give her what she needs spiritually! The example of Christ loving the church is the model for husbands to love their wives unconditionally. Christ sacrificed himself to make the church pure, holy, and blameless. My brothers, have you made it your desire to sacrifice your time and attention and recreation and sports to make your wife

74

everything she should be spiritually? Once you have, you will see a tremendous difference in her life. Let's say it will be more profitable for you!

As we said before, cherish your wife. Normally when we think of cherishing our wives we think of putting her up on a pedestal, where we can adore everything about her. But that's not the idea of this word. Really, this word conveys the idea of "warming" her up.

Some men say right away, "That's my wife. She's cold as anything—sexually, emotionally, you name it. She's as cold as a dead fish!" Guess what, whose job is it to warm her up? It's the husband's job!

To cherish your wife, you treat her warmly, tenderly, affectionately so that her heart is open and responsive to you. Men, be gentle with your wives. The same term used for "cherishing" our wives is used in 1 Thessalonians 2:7: "But we were gentle among you, like a mother caring for her little children." This idea of cherishing is tied to the idea of gentleness. Men, if you want your wives to warm up to you, try being gentle, which leads to being a gentleman.

Most men don't get the response they want from their wives, so they become forceful, yelling, screaming, becoming verbally insulting and abusive. Perhaps this reaction is not working for you at all. Instead, men, if you will turn gentle and soft, you will find it warms your wife's heart more toward you.

A wife frequently malnourished of attention will find a way to be sustained. It may not be the right or popular way; however, she will become creative and prevent starvation of attention. So, men, stop the madness, stop the *foolishness* by maintaining a healthy diet of time, care, and attention. You will be glad you did!

Chapter Seven

Carrying the Load

I grew up in a household of three brothers, one sister, and three aunts. We had ten people living in a 1,200-square-feet home. It may be to your surprise, but we were all happy together. Back in the day, material things were not the number one priority of the home. As long as the house was clean, food was cooked, everybody was fed, and we considered ourselves blessed. Out of five children, I was number 4, which back in the day was called the knee-baby. If we were poor, my parents sure didn't let us in on it.

In our home, we were taught that the man should carry the majority of the load because God made him the head (the responsible person). My dad worked very hard and led by example by working overtime to care for the family. He also had a lawn care service and trash pickup service where he employed my brothers willingly or unwillingly because he believed that the man should carry the load. My mom also worked on and off outside the home in order to help with the household bills. She'd work at Shoney's as a waitress and brought home lots of tips. Shoney's at that time was a premier restaurant. Oh, how I remember those days when my mother would bring home those Big Boy Shoney's burgers with fries and we thought that was the life. My mother would take her tips and take care all of the smaller needs of the household. Mom was a very straightforward person and meant what she said. She made sure we kept the house clean and made sure we were well kept as well. She made sure the house

was kept in order while my dad was out making money to carry the majority of the load necessary to keep all of us wanting nothing.

Years later, I found out that we didn't have much, but we had God and lots of love that kept us very close. We were enjoying life to the fullest.

How I Grew Up

Growing up, I was labeled as a tomboy. *A tomboy was a girl who enjoys rough, noisy activities traditionally associated with boys (none of this funny stuff).* While my sister was doing girly things, I was playing with my brothers. Unlike now, I did not like wearing dresses and pumps. However, something changed once I reached my senior year. I begin to walk and feel a little differently as I developed into a young lady. Upon graduation, I thought I wanted to be a model for a clothing line in Atlanta, Georgia. Of course, my father intervened and said no under any circumstances was his daughter going to subject herself to a business that exploits women. That was his belief of the industry. Well, what I thought I wanted to do and what my father said clashed. You already know: my father won.

As I began the transition into a young adult, my mom used to tell me that when I got older, ain't no young man going to want me because I would not pay attention when she was trying to teach me how to cook, sew, and clean. Little did she know, I was paying attention. After I married the love of my heart, she later praised me for keeping a clean house and throwing down in the kitchen. As a matter of fact, my husband, children, and friends praised and complimented me often when I cook (not often now). Even now when I cook, my family and friends really make me feel that they really like my cooking. They truly act like I'm the best cook they have ever seen. I believe they do that for me to cook more often.

I must say my mother and father trained me well, and for that, I'm thankful. My mother went on to be with the Lord, September 8, 2016. I truly do miss her so very much, but I know I'll see her again in glory. My dad is still holding on and moving forward.

In our society today, many women are carrying the load of the home. I believe this is one of the reasons why women are acting *foolish*—because we were not built to carry the load. I'm sure by now after reading this book, you've figured out that the woman was not designed to carry but so much of the load. Naturally, a woman as a whole is not built to carry things in the same manner as a man. Now, I know that there are some women out there that beg to differ with me, but listen to me carefully. *A woman perhaps may be more stronger mentally than a man; however, she's not normally built to be stronger than a man physically.* There are some exceptions (women weightlifters).

Trained by my brothers, especially my oldest brother Alvin, I learned to play basketball in the backyard on a dirt court. I must say I was pretty good at being a shooting guard. I thought I could do everything my brothers did, but my father and mother always reminded me that I was a woman, and they trained me to keep my femininity regardless of what I did with my brothers. My dad did not allow me to work with him during his lawn care service. However, he taught the boys to pull their load and earn their living by working hard. He always taught us that the man should be the man by being a great provider and the woman should be the woman by knowing that she's a helper and not the sole provider.

How Things have Changed

Now, you may be wondering, do I think different about life, seeing how things have changed? I do believe that women should not lose themselves when entering into a marriage, but I will say this. A husband and a wife should sit and decide and set goals for their families. The husband should be the first partaker and be responsible for the well-being of the household. There should always be a vision and goals set for the family. Every family should be led by the man and the vision that God gave him for his family. The Bible says "without a vision the people perish" (Proverbs 29:18). Husbands, you must be in a place to hear from God and lead your family.

My husband and I have always worked as a team. He would always talk about where he's going in life. He set the bar real high for the Bee household. Although he was enlisted in the Air Force, he has always provided well for me and the children. I stayed at home for twelve years in order to raise our children in a godly home. I homeschooled them for three years and later started the first School for HomeSchoolers in Middle Georgia. This later led me to be the founder of Christian Fellowship Academy (CFA), renamed as "The Winning Academy (TWA)." This was a huge leap of faith, but I knew that God wanted me to do this and here we are now twenty-plus years, still on the wall. The vision (the Will of God) that God gave me has never been in conflict with the vision (the Will of God) that God gave my husband. As a matter of fact, they complement each other.

I understand that women today are carrying heavy loads, but is that the way God intended for it to be?

It is because of the change of time?

Is it because of rebellion against the way it's supposed to be?

Is it because someone is not in their rightful place?

We should never let society dictate to us how our lives should be. The Word of God is a lamp unto our feet and light into our pathway (Psalms 119:105).

I am not writing this book to be at odds with anybody, but I'm just being a mouthpiece for Jesus. So many of our lives are out of order. That's because we have taken matters into our own hands. God is the Author and Finisher of our faith according to (Hebrews 12:2). We must follow God's plans and not our own. There's another scripture that says, "There's a way that seems right unto a man; but the end thereof is destruction" (Proverbs 14:2). God's way of life is totally different from what man sees.

There are many controversial issues out in our society on what a woman can do versus a man. God didn't create us to be in competition with one another. If that was the case, He could have made us all the same. There's a reason God made male and female. He made us, so we do not have the right to redefine His creation. How would you like it if you created something and someone comes on the scene

and redefines your creation? You would become unglued about that. Well, same thing with God, He has every right to tell the creation what the Creator expects out of them or it.

God holds the man responsible regardless of what man says. Even if the man does not except his responsibility, God does not let him off the hook. Husbands and wives must take their rightful place, rightful role, and rightful position so that the marriage and family will be blessed by God. Men and women alike must seek God and ask Him for His guidance, His wisdom, and an understanding of His Word.

Many people have questions that need to be answered about how things are supposed to be. Well, one source we can always turn to is God's Word. God is all-knowing, and His ways are not our ways. The Word of God is the final, absolute, and pure Word of God. We can't add to it or take from it; it will be a detriment to our souls.

Let's go back to the beginning. We do know that God made man first, made him the head, and gave him a job. In other words, he had responsibilities before woman came on the scene.

> *And the Lord God took **the man**, and put him into the garden of Eden to **dress it and to keep it**.* (Gen. 2:15)

> The Lord God put the man in the Garden of Eden to *take care of it and to look after it*. (Gen. 2:15, CEV)

> *And out of the ground the Lord God formed every beast of the field, and every fowl of the air; and brought them unto Adam to see what he would call them: and whatsoever **Adam called every living creature, that was the name thereof.***

> *And **Adam gave names** to all cattle, and to the fowl of the air, and to every beast of the field; but for Adam there was not found an help meet for him.* (Gen. 2:19–20)

Your food will be plants,
but the ground
will produce
thorns and thistles.
You will have to sweat
to earn a living;
you were made out of soil,
and you will once again
turn into soil. (Gen. 3:18–19, CEV)

I still believe that the male should dress and keep his family, or shall I say take care of and look after his family. The male was designed and assigned this duty from the annals of time. So *the proper order of things is for the man to carry the load, not in word, but in deed.* If the woman is carrying the load, the order is disarranged. She's to flow with the order by assisting with the load.

The Me-Too Movement

In our modern day, we've seen a plethora of sexual misconduct and abuse because women are trying to measure up and carry the load on their own. Many have placed themselves in a place of no return because of their need of an income. The marriages are going through rough times because of so much debt in the household. The homes are in an overload of debt, so therefore it takes two income just to keep the home life flowing. Once the household has built up a lot of debt, the wife cannot quit her job for any reason because of so much debt. Therefore, they find themselves playing the game of getting to the top where they find themselves feeling trapped and can't say no to something that's questionable and goes against their morals and beliefs.

Before even now, there have been sexual accusations, allegations, harassment, misconduct, abuse, assault, and violent predators on the loose among our politicians, businessmen, policemen, priest, and other professionals. There is an extensive list of high-profile men

who have been pointed out of a lineup for this egregious behavior. In the past, women were too afraid to come forward. However, here recently, we have had more women join the "Me Too" movement and have let their voices be heard in the media about their experiences in the workplace. They are protesting sexual assault in the workplace. As far as I'm concerned, there should be zero tolerance for this type of conduct.

It is long overdue for women all over the world to stand up and be counted as a person on an equal playing field of the workforce. Also, men need to take responsibility and see to it that women are treated fairly in corporate America and internationally abroad. If men did not want us in the workplace, they shouldn't have allowed us in, but now that we are here, we are here to stay. So there must be some effort to work with the female without sexually exploiting her.

Wouldn't it be great if men got paid enough for carrying the entire load of the household? There are a great number of women who would not act *foolish* if her man was compensated for his worth. On the other hand, can you imagine that if every man got paid for what he was worth, most women would go home and not come back? Women truly do not want to compete with other males and females to live a comfortable lifestyle.

If you desire a woman not to act *foolish*, carry your load that was assigned to you as a husband. Men, make no mistake about it; we're not saying that you do anything to bring home more money. Market yourself to gain an improved life for you and your family.

Chapter Eight

Commitment

Understanding Commitment

What is commitment? Here is the true meaning—*I have made my allegiance to you; regardless of what happens along the way, I am obligated until the end.* It's been asked, "What is the greatest word in a relationship?" Many have said without thinking, "Love." But after further review, I believe the greatest and strongest word in a relationship is *commitment*. What happens when the love runs out? What happens when they say, "The love is gone"? What happens when things change altogether? To answer these questions, I believe commitment is the best answer anyone can give because when love is not there, commitment says, "Regardless I'm here." You may have heard many people say, "I don't feel the love anymore." "I'm not in love with him or her anymore." *Whether or not you feel love or not, commitment says, "Even if I don't feel it or see it, I'm here to stay."* Despite the prevailing circumstances, we were determined to stay together regardless. If we have this mind-set, *foolishness* would have to take a backseat in our relationships.

Cultural values, our job, the children, our hobbies, negative peer pressure, and certainly our own selfishness, all compete with our commitment to our spouse in marriage. So we must learn to develop or restore commitment to our spouse in marriage.

Commitment to our spouse will help us persevere through hard times in marriage because hard times will come. Some hard times

come in the first three years of marriage when two selfish single adults struggle to become one. For others, the challenge to be committed comes with each new baby, each new career, and so forth. For some, temptation to be unfaithful comes with a loss of purpose in life.

Commitment is needed to successfully persevere through these hard times common to all marriages. But commitment is also needed to stay in marriages when complications arise, such as physical or psychological illness, addiction, unresolved hurts, or dissatisfaction in marriage for one reason or another.

Commitment channels all of our spiritual, mental, emotional, and physical energies to finding solutions rather than siphoning away some of our energies to devising escape plans. Commitment is not the whole answer, but is key to staying together in marriage and working to find solutions. A lack of commitment will render even good solutions powerless to help in marital problems and remove hope of experiencing a loving marriage.

Here are some benefits to a loving marriage. A loving marriage lays the foundation to a successful family. If you are married, a loving marriage will encourage you to be intimate with God in prayer. If you are married, a loving marriage will increase your career success. If you are married, a loving marriage will boost your self-image. You will have a constant encourager, a sense of security and fulfillment in life.

We must build this kind of commitment with our spouse in marriage that enables us to work through hard times and work toward a loving marriage.

After being married for over thirty-six years, my husband and I are committed to our marriage until death do us part. How? Because we are committed to God first, each other, and then our calling. Yes, in that order. Without God being first, there is no way we can succeed with the other two. And so in Deuteronomy chapter 6, God says to Israel that if you want your families to succeed in life, if you're truly committed to your household, then here's what you have to do:

And thou shalt love the Lord thy God with all thine heart, and with all thy soul, and with all thy might.

And these words, which I command thee this day, shall be in thine heart:

And thou shalt teach them diligently unto thy children, and shalt talk of them when thou sittest in thine house, and when thou walkest by the way, and when thou liest down, and when thou risest up.

And thou shalt bind them for a sign upon thine hand, and they shall be as frontlets between thine eyes.

And thou shalt write them upon the posts of thy house, and on thy gates.

And it shall be, when the Lord thy God shall have brought thee into the land which he sware unto thy fathers, to Abraham, to Isaac, and to Jacob, to give thee great and goodly cities, which thou buildedst not,

And houses full of all good things, which thou filledst not, and wells digged, which thou diggedst not, vineyards and olive trees, which thou plantedst not; when thou shalt have eaten and be full;

Then beware lest thou forget the Lord, which brought thee forth out of the land of Egypt, from the house of bondage.

Thou shalt fear the Lord thy God, and serve him, and shalt swear by his name. (Deut. 6:5–13)

This is the formula for success: Put God first in your family.

What is the formula to success? Commitment to God first. Put God first in your marriage! Put God first in your family! Put God first in what you teach your children! Put God first in how you live your life!

Commit to the LORD whatever you do, and your
plans will succeed. (Proverbs 16:3)

Now, there are people who believe the pagan concept of "God helps those who help themselves." This is a false doctrine. It is not biblical. God has NEVER said that and has NEVER endorsed that. God does not help those who help themselves. *God helps those who honor Him and put Him first in their lives.*

But seek ye first the Kingdom and His righteous, and
all these things shall be added unto you. (Matthew 6:33)

What God is telling us in Deuteronomy chapter 6 is we must love God with all our heart and keep Him first. We must teach our kids to love God with all their heart as well. Ask God to teach us how to love Him so that we can learn how to love others and deal with life as life happens. Asking God for help is not a *foolish* thing. When your children see you asking God for help, then they too will know that He will help them in the time of need.

If you and I make it a constant part of our life to REMEMBER what God has done for us in the past (when we have been faced with life difficulties and obstacles in our lives); we'll be more inclined to look to God for help when we encounter other problems in life as we grow in His grace.

Now, you can do what you want to, but I'm not too proud to ask God for help!

I have asked Him for help for the following:

Marriage
Children
Family
Finances
Spiritual growth
Leadership
Career

Health
Community
Decisions

God said in Psalm 46:1: "God is our refuge and strength, a very present help in time of need." As you live life, you will have some type of need in every area of your life, so ask for help from God.

Chapter Nine

Learning How to Love Regardless of Imperfections

As you have read previously in chapter 5, we are to strive to love like Christ with agape love. Love in spite of not because of. We as humans tend to love those who love us and hate those who hate us. We find it hard to love someone who doesn't love us and love someone who have done us wrong. It takes the love of Christ to love like you never being hurt. Many times we have never been taught how to love ourselves through our own imperfections, so it makes it difficult to love others with their imperfections. The world has taught us to highlight others' imperfections and diminish our own. It is so easy to talk about others' imperfections and not deal with our own. Nobody's perfect, neither are you!

Regardless of how many things you do right, there are some things that you have and will do wrong. Why? Because you are not perfect—none of us are. Women act *foolish* when we think that no one is perfect but them. We're deceived, thinking that we're the only one that's right, which is far from the truth. Just like you want others to put up with your imperfection, you must learn to put up with others' imperfections in life.

The Power of Loving through Imperfections

*Hatred stirreth up strifes; but **love covereth all sins.*** (Prov. 10:12)

According to Genesis 29:20, Jacob worked fourteen years for his love Rachel, and it seemed unto him as a few days. Jacob shows us that when you love someone, nothing will keep you from pursuit of their love. Jacob gives us a snapshot of what real love is all about.

What Is Real Love?

Most men and women act *foolish* because they don't know what real love is. I had a man tell me he only believed in what he could see. I asked if he was sure. "Of course," he said. I asked him, "Have you ever seen love?" He said, "Yes." I said, "What did it look like?" He couldn't answer the question. No one has ever seen love, but we can see the effects of love around the world. We have a duty to instill love for others by doing for others. *Real love loves regardless of imperfections.*

John 3:16 is the most quoted scripture in the world: "For God so loved the world that He Gave His only begotten Son." God gave His Son to us. Now real love is about giving!

Love is not what it says, but love is what it does.

Love is not love until you have given love a way.

You can give without love, but you can't love without giving.

Can you imagine how much Jacob loved Rachel? He worked for her seven years and did not get her. His love for Rachel was so strong until he worked another seven years, which he said that it seemed unto him as a few days. Wow, what love will do! Is there waiting love today? The person that needs your love the most probably deserves it the least.

Do we practice real love on a daily basis?

Listen as you read what *1 Corinthians chapter 13* from the *Easy-to-Read Version (ERV)* has to say about love:

Let Love Be Your Guide

I may speak in different languages, whether human or even of angels. But if I don't have love, I am only a noisy bell or a ringing cymbal.

I may have the gift of prophecy, I may understand all secrets and know everything there is to know, and I may have faith so great that I can move mountains. But even with all this, if I don't have love, I am nothing.

I may give away everything I have to help others, and I may even give my body as an offering to be burned. But I gain nothing by doing all this if I don't have love.

Love is patient and kind. Love is not jealous, it does not brag, and it is not proud.

Love is not rude, it is not selfish, and it cannot be made angry easily. Love does not remember wrongs done against it.

Love is never happy when others do wrong, but it is always happy with the truth.

Love never gives up on people. It never stops trusting, never loses hope, and never quits.

Love will never end. But all those gifts will come to an end—even the gift of prophecy, the gift of speaking in different kinds of languages, and the gift of knowledge.

These will all end because this knowledge and these prophecies we have are not complete.

But when perfection comes, the things that are not complete will end.

When I was a child, I talked like a child, I thought like a child, and I made plans like a child. When I became a man, I stopped those childish ways.

It is the same with us. Now we see God as if we are looking at a reflection in a mirror. But then,

*in the future, we will see him right before our eyes.
Now I know only a part, but at that time I will
know fully, as God has known me.*

 *So these three things continue: faith, hope, and
love. And the greatest of these is love.*

So one must ask themselves, "Do I really love?"
Do people look at you and say, "Is that what love is all about?"
Can love and fear coexist? Absolutely not!
What do you see when you see your spouse?
What do they see when they see you?
What you love you will find time for.

If you hurt today, will your spouse invest in the love to get you beyond the storm? That is not the question. The question is, Can you see your spouse hurting, and how can you invest love in them to help them grow and overcome?

Here are some small suggestions:

- Pray for them
- Encourage them
- Comfort them
- Call or text them
- Hug and kiss them
- Write them

All these actions show and prove that you really care and love them, and that really means a lot to your spouse.

Always look for ideas that will let your spouse know that they are on your mind constantly. Say kind and encouraging words; this will let your spouse know that you want what's best for them.

Many don't believe this, but I found out that prayer is the key to your change. Prayer can do what cannot be accomplished. Oftentimes while we pray for others to change, it is our heart that need changes. If you do not like what you are getting, *change what you are giving*!

This reminds me of the parable of the rose. A certain man planted a rose and watered it faithfully, and before it blossomed, he examined it. He saw the bud that would soon blossom, but noticed thorns upon the stem and he thought, "How can any beautiful flower come from a plant burdened with so many sharp thorns?" Saddened by his thought, he neglected to water the rose, and before it was ready to bloom, it died. So it is with many people. Within every soul there is a rose; you must keep watering your rose.

Many of us look at ourselves and our spouses and see only the thorns, the faults, the problems, the defects, the disappointments. We despair, thinking that nothing good can come possibly from imperfect people. We neglect to water the good within us, and eventually it dies. We never realize our potential until it's too late.

Some people do not see the rose within themselves; someone else must show it to them. One of the greatest gifts a person can possess is to be able to reach past the thorns and find the rose within others. This is a characteristic of love—to look at a person and know their true worth. When love is the motive, the job will be finished and the goal accomplished, accepting that person into your life while recognizing the nobility in their soul. Help them to realize that they can overcome their faults. If we will show them the rose, they will conquer their thorns. Only then will they blossom many times over.

It's been said that some people grumble that roses have thorns.

I'm thankful that thorns have roses. The thorns help you to see the beauty of the rose. Without the thorns, there would be no beauty of a rose.

Love overlooks many things; the lack of love is constantly finding faults.

After reading 1 Corinthians chapter 13, one must wonder, "Do I really know how to love?" I encourage you to read First Corinthians chapter 13 over and over again and evaluate yourself. Love must become a practice. You practice by giving love to someone daily. So invest in someone as God invested in you! Love gives! Love loves to give!

How to Love Your Spouse

> *And above all things have fervent charity among yourselves: for **charity shall cover the multitude of sins.*** (1 Pet. 4:8, KJV)

> *Most important of all, you must sincerely love each other, because **love wipes away many sins.*** (1 Pet. 4:8, CEV)

> *Most important of all, love each other deeply, because **love makes you willing to forgive many sins.*** (1 Pet. 4:8, ERV)

> *Most important of all, continue to show deep love for each other.* (1 Pet. 4:8, TLB)

Please encircle that word "show." That word indicates that it's not enough to have love in your heart—you must SHOW love in your life! Many act *foolish* because they do not know how to show love.

There's no question that every one of us wants to be loved and to love others. But it's not enough for others to know that you love them—you must SHOW you love others! Love is not an abstract idea. Love must be manifested. True love is not just something you feel—it's something you demonstrate!

Marriages have problems when partners don't show love to one another. A husband and wife may love each other deeply but have a miserable marriage because they don't know how to show their love for each other.

You can't raise kids properly without showing them love. You can't have true lasting, satisfying friendships if your friends can't tell that you love them. You can't experience relationships in the community or in your church family without showing and receiving love.

For some of you, showing love is not a problem. For some of you, it's easy to show love. It comes naturally to you because of your

temperament or because of how you were raised. Others of you have a more difficult time showing love. You don't feel comfortable showing your love. You may simply have never learned how to show love because it was never shown to you as a child.

But whether it comes natural or not, we all need to grow in this area because everybody needs to know they are loved. You especially needs to know how to show love if you are a follower of Christ because Jesus said, "All people will know that you are my followers if you love each other" (John 13:35, NCV).

The Five Laws of Showing Love

1. Treat others just as you want to be treated.

This has been called "the Golden Rule" because it is so valuable. It's like gold.

You want others to treat you with love and respect, and there's nothing wrong with that. Jesus uses something you can readily understand to teach you something you need to know. You need to treat others just as you want to be treated. You want others to listen to you when you talk. You want them to think about your needs. You want them to take the initiative in seeking you out. You want them to show you love by the things they do for you. You want their love and forgiveness when you misbehave. You want understanding and second chances.

Jesus says, then you need to start doing that for others. Start listening when they talk. Be interested in what they're saying—don't just yawn and look away while they're talking. Don't just be thinking about what you're going to say next—really focus on what they're saying.

Start taking the initiative in seeking others out. Start meeting their needs. Start showing them love by the things you do. Forgive others and be patient with them. Be kind and understanding even when they aren't acting right.

This great guideline of Jesus is pretty simple. It's pretty straight-forward. It's pretty well known. But it's also pretty easy to overlook because of our human weaknesses. So we need to be reminded.

> *Love is patient and kind. Love is not jealous or boastful or proud 5 or rude. Love does not demand its own way. Love is not irritable, and it keeps no record of when it has been wronged. 6 It is never glad about injustice but rejoices whenever the truth wins out. 7 Love never gives up, never loses faith, is always hopeful, and endures through every circumstance.* (1 Cor. 13:4, NLT)

The second law of love builds on the first one. Not only should you treat others the way you want to be treated, but you should also do the following:

2. Treat others the way Jesus treats you.

In other words, *give yourself away to others.*

> *So now I am giving you a new commandment: Love each other. (And then Christ tells us HOW to love each other.) Just as I have loved you, you should love each other.* (John 13:34, NLT)

Jesus reemphasized this factor in *John 15:12.*

> *"I command you to love each other in the same way that I love you."* Jesus says, "I want you to love others the way I love you. I want you to treat others the way I treat you."

That's pretty good treatment! Some have even dubbed this "the Platinum Rule." The Golden Rule is to treat others the way you want

to be treated and one step up from that is to treat them the way Jesus treats you!

All you have to do is ask yourself, "How does Christ treat me? That's how I need to treat others."

How does Christ show His love for you? That's the way you need to show your love to others.

Five times the New Testament flatly declares that Jesus "gave Himself" for you (Gal. 1:4, 2:20; Eph. 5:25; 1 Tim. 2:6; and Titus 2:14). Let's look at the following quote:

> *I myself no longer live, but Christ lives in me. So I live my life in this earthly body by trusting in the Son of God* (In other words, Paul is saying, "Christ is now calling the shots in my life. He's my leader." Why would he say that?), *who loved me and gave himself for me.* (Gal. 2:20)

That's how much Christ loved you. He loved you so much He gave Himself for you. That's how He showed His love for you. He didn't just talk about loving you. He proved how much He loved you by giving Himself, by coming to earth as a human being, by living and dying for you.

That's great love! If you ever begin to feel unloved, if you get to the place that you think no one loves you, look at the cross of Jesus! He loves you so much He was willing to die for you! God is not just a God who talks about love. He shows you how much He loves you! And that's what He wants us to do for others.

If you're going to love others the way Christ loves them, you're going to have to give yourself like Christ gave Himself.

3. Take delight in honoring others.

> *Love each other with genuine affection, and take delight in honoring each other.* (Rom. 10:10, NLT)

in the future, we will see him right before our eyes.
Now I know only a part, but at that time I will
know fully, as God has known me.

> *So these three things continue: faith, hope, and*
> *love. And the greatest of these is love.*

So one must ask themselves, "Do I really love?"
Do people look at you and say, "Is that what love is all about?"
Can love and fear coexist? Absolutely not!
What do you see when you see your spouse?
What do they see when they see you?
What you love you will find time for.

If you hurt today, will your spouse invest in the love to get you beyond the storm? That is not the question. The question is, Can you see your spouse hurting, and how can you invest love in them to help them grow and overcome?

Here are some small suggestions:

- Pray for them
- Encourage them
- Comfort them
- Call or text them
- Hug and kiss them
- Write them

All these actions show and prove that you really care and love them, and that really means a lot to your spouse.

Always look for ideas that will let your spouse know that they are on your mind constantly. Say kind and encouraging words; this will let your spouse know that you want what's best for them.

Many don't believe this, but I found out that prayer is the key to your change. Prayer can do what cannot be accomplished. Oftentimes while we pray for others to change, it is our heart that need changes. If you do not like what you are getting, *change what you are giving!*

This reminds me of the parable of the rose. A certain man planted a rose and watered it faithfully, and before it blossomed, he examined it. He saw the bud that would soon blossom, but noticed thorns upon the stem and he thought, "How can any beautiful flower come from a plant burdened with so many sharp thorns?" Saddened by his thought, he neglected to water the rose, and before it was ready to bloom, it died. So it is with many people. Within every soul there is a rose; you must keep watering your rose.

Many of us look at ourselves and our spouses and see only the thorns, the faults, the problems, the defects, the disappointments. We despair, thinking that nothing good can come possibly from imperfect people. We neglect to water the good within us, and eventually it dies. We never realize our potential until it's too late.

Some people do not see the rose within themselves; someone else must show it to them. One of the greatest gifts a person can possess is to be able to reach past the thorns and find the rose within others. This is a characteristic of love—to look at a person and know their true worth. When love is the motive, the job will be finished and the goal accomplished, accepting that person into your life while recognizing the nobility in their soul. Help them to realize that they can overcome their faults. If we will show them the rose, they will conquer their thorns. Only then will they blossom many times over.

It's been said that some people grumble that roses have thorns.

I'm thankful that thorns have roses. The thorns help you to see the beauty of the rose. Without the thorns, there would be no beauty of a rose.

Love overlooks many things; the lack of love is constantly finding faults.

After reading 1 Corinthians chapter 13, one must wonder, "Do I really know how to love?" I encourage you to read First Corinthians chapter 13 over and over again and evaluate yourself. Love must become a practice. You practice by giving love to someone daily. So invest in someone as God invested in you! Love gives! Love loves to give!

How to Love Your Spouse

> *And above all things have fervent charity among yourselves: for* **charity shall cover the multitude of sins.** (1 Pet. 4:8, KJV)

> *Most important of all, you must sincerely love each other, because* **love wipes away many sins.** (1 Pet. 4:8, CEV)

> *Most important of all, love each other deeply, because* **love makes you willing to forgive many sins.** (1 Pet. 4:8, ERV)

> *Most important of all, continue to show deep love for each other.* (1 Pet. 4:8, TLB)

Please encircle that word "show." That word indicates that it's not enough to have love in your heart—you must SHOW love in your life! Many act *foolish* because they do not know how to show love.

There's no question that every one of us wants to be loved and to love others. But it's not enough for others to know that you love them—you must SHOW you love others! Love is not an abstract idea. Love must be manifested. True love is not just something you feel—it's something you demonstrate!

Marriages have problems when partners don't show love to one another. A husband and wife may love each other deeply but have a miserable marriage because they don't know how to show their love for each other.

You can't raise kids properly without showing them love. You can't have true lasting, satisfying friendships if your friends can't tell that you love them. You can't experience relationships in the community or in your church family without showing and receiving love.

For some of you, showing love is not a problem. For some of you, it's easy to show love. It comes naturally to you because of your

temperament or because of how you were raised. Others of you have a more difficult time showing love. You don't feel comfortable showing your love. You may simply have never learned how to show love because it was never shown to you as a child.

But whether it comes natural or not, we all need to grow in this area because everybody needs to know they are loved. You especially needs to know how to show love if you are a follower of Christ because Jesus said, "All people will know that you are my followers if you love each other" (John 13:35, NCV).

The Five Laws of Showing Love

1. Treat others just as you want to be treated.

This has been called "the Golden Rule" because it is so valuable. It's like gold.

You want others to treat you with love and respect, and there's nothing wrong with that. Jesus uses something you can readily understand to teach you something you need to know. You need to treat others just as you want to be treated. You want others to listen to you when you talk. You want them to think about your needs. You want them to take the initiative in seeking you out. You want them to show you love by the things they do for you. You want their love and forgiveness when you misbehave. You want understanding and second chances.

Jesus says, then you need to start doing that for others. Start listening when they talk. Be interested in what they're saying—don't just yawn and look away while they're talking. Don't just be thinking about what you're going to say next—really focus on what they're saying.

Start taking the initiative in seeking others out. Start meeting their needs. Start showing them love by the things you do. Forgive others and be patient with them. Be kind and understanding even when they aren't acting right.

This great guideline of Jesus is pretty simple. It's pretty straight-forward. It's pretty well known. But it's also pretty easy to overlook because of our human weaknesses. So we need to be reminded.

Love is patient and kind. Love is not jealous or boastful or proud 5 or rude. Love does not demand its own way. Love is not irritable, and it keeps no record of when it has been wronged. 6 It is never glad about injustice but rejoices whenever the truth wins out. 7 Love never gives up, never loses faith, is always hopeful, and endures through every circum-stance. (1 Cor. 13:4, NLT)

The second law of love builds on the first one. Not only should you treat others the way you want to be treated, but you should also do the following:

2. Treat others the way Jesus treats you.

In other words, *give yourself away to others.*

So now I am giving you a new commandment: Love each other. (And then Christ tells us HOW to love each other.) Just as I have loved you, you should love each other. (John 13:34, NLT)

Jesus reemphasized this factor in *John 15:12.*

"I command you to love each other in the same way that I love you." Jesus says, "I want you to love others the way I love you. I want you to treat others the way I treat you."

That's pretty good treatment! Some have even dubbed this "the Platinum Rule." The Golden Rule is to treat others the way you want

to be treated and one step up from that is to treat them the way Jesus treats you!

All you have to do is ask yourself, "How does Christ treat me? That's how I need to treat others."

How does Christ show His love for you? That's the way you need to show your love to others.

Five times the New Testament flatly declares that Jesus "gave Himself" for you (Gal. 1:4, 2:20; Eph. 5:25; 1 Tim. 2:6; and Titus 2:14). Let's look at the following quote:

> *I myself no longer live, but Christ lives in me. So I live my life in this earthly body by trusting in the Son of God* (In other words, Paul is saying, "Christ is now calling the shots in my life. He's my leader." Why would he say that?), *who loved me and gave himself for me.* (Gal. 2:20)

That's how much Christ loved you. He loved you so much He gave Himself for you. That's how He showed His love for you. He didn't just talk about loving you. He proved how much He loved you by giving Himself, by coming to earth as a human being, by living and dying for you.

That's great love! If you ever begin to feel unloved, if you get to the place that you think no one loves you, look at the cross of Jesus! He loves you so much He was willing to die for you! God is not just a God who talks about love. He shows you how much He loves you! And that's what He wants us to do for others.

If you're going to love others the way Christ loves them, you're going to have to give yourself like Christ gave Himself.

3. Take delight in honoring others.

> *Love each other with genuine affection, and take delight in honoring each other.* (Rom. 10:10, NLT)

This is a very practical thing you can do to show someone you love and appreciate them. Give them recognition. Give them attention. Everybody needs attention. Everybody needs to be honored from time to time.

Spouses need to honor one another. Children need to honor their parents. That's even one of the Ten Commandments: "Honor your father and mother." You need to honor your family and friends, your pastor, your coworkers, your boss, your employees, and anyone in your life that you love.

The Bible says we need to take delight in honoring others. We need to look for opportunities to show others what they mean to us. It might be a kind word or maybe a small gift. It might be a pat on the back or a compliment. Little things can make a big difference in the life of someone you love.

Here's another law of love:

4. Meet others' needs.

> *What if a person has enough money to live on and sees his brother in need of food and clothing? If he does not help him, how can the love of God be in him? 18 My children, let us not love with words or in talk only. Let us love by what we do and in truth.* (1 John 3:17–18, NCV)

5. Love others by faith.

> *I pray that Christ will live in your hearts by faith and that your life will be strong in love and be built on love.* (Eph. 3:17, NCV)

Sometimes you're not going to feel like it, but like so many others areas of your life you're going to have to love by faith.

You've got to show love even if you don't feel love. That's not being hypocritical. That's living by faith.

Keep or Kill Your Relationship

You will keep your friends if you forgive them, but you will lose your friends if you keep talking about what they did wrong. (Prov. 17:9, CEV)

It is so easy to find fault with everyone and everything else other than yourself. It is *foolish* to kill what you can keep, knowing that you need it anyway. Many have lost out because their pride won't let them forgive and move on in life. Maintaining a healthy relationship means forgiving rather than dwelling on faults. According to this proverb, we should be willing to disregard the faults of others. Forgiving faults is necessary to any relationship. It is tempting, especially in an argument, to bring up all the mistakes the other person has ever made. Just remember, you have made some mistakes too. Love, however; keeps its mouth shut—difficult though that may be. Try never to bring anything into an argument that is unrelated to the topic being discussed.

It's like the husband who was talking to his buddy. He said, "Every time my wife and I get into intense fellowship, she gets historical."

"Don't you mean hysterical?" said the friend.

"No," said the husband. "She gets historical. She tells me everything I ever did to her."

If you continue to emphasize some piece of information for years and years, that is going to kill what can be kept through forgiveness.

As we grow to be like Christ, we will acquire God's ability to forget the confessed sins of the past.

Let's take these words to heart and put them to action!

Notes

From Wikipedia, the free encyclopedia

C. S. Lewis, *The Four Loves* (1960) p. 8–20

Zig Ziglar, *Courtship After Marriage: Romance Can Last A Lifetime.* Nashville: Thomas Nelson, 1990.

Willard F., Jr., *His Needs, Her Needs for Parents—Keeping Romance Alive.* Michigan: Fleming H. Revell, 2003.

https://www.biblegateway.com: A Searchable Online Bible

Debra White Smith and Daniel W. Smith, *Romancing Your Wife— A Little Effort Can Spice Up Your Marriage*, Oregon: Harvest House Publishers, 2003.

Dr. Myles Munroe, *Understanding The Purpose and Power of Men.* Pennsylvania: Whitaker House, 2001.

Dr. Myles Munroe, *Understanding The Purpose And Power of Woman.* Pennsylvania: Whitaker House, 2001.

Dr. Myles Munroe, *The Purpose And Power of Love & Marriage.* Pennsylvania: Destiny Image Publishers, Inc., 2002.

Dr. Henry Cloud and Dr. John Townsend, *Boundaries In Marriage.* Michigan: Zondervan Publishing House, 1999.

About the Author

Dr. Veronica G. Bee, along with her husband, Dr. Harvey B. Bee, are the founders of Christian Fellowship Church (CFC), aka "The Winning Church." The Bees have been in ministry together since 1984.

Dr. Bee is committed to the call to make a difference in her community.

As a pioneer, she started the first School for Home Schoolers in Middle Georgia. Her notable example of excellence led her to be founder of Christian Fellowship Academy in 1999, now known as "The Winning Academy." As a businesswoman, she is the co-owner of Alexis II Beauty Salon in Warner Robins/Centerville.

Dr. Bee earned a doctor of philosophy degree in Christian Education from Minnesota Graduate School of Theology in June 2002.

Dr. Bee is dedicated to what the Bible says about faith, family, and finances. She has developed a passionate love to help people develop a love for God, a love for themselves, and a love for their families.

Dr. Bee is a profound teacher of the Word of God. Whenever you listen to her speak, you will always be inspired to know God intimately and live according to His standards for yourself.

One of Dr. Bee's favorite scriptures is Ephesians 3:20: *"Now unto him that is able to do exceeding abundantly above all that we ask or think, according to the power that worketh in us."* Her endeavor is to always practice what she preaches.

Dr. Bee is united in covenant with the love of her life, Dr. Harvey B. Bee, of thirty-six years. They have three wonderful children, Carlos, Jarius, and Mira and four grandchildren. She truly believes strongly in her marriage and her family. This is her first ministry.

Dr. Bee is the epitome of a woman with Godly character, integrity, and virtue!

OFFICE
621 Walnut Street
Warner Robins, GA 31093
PHONE
478.975.0808
FAX
478.975.0809
EMAIL
vbee@winning.church
WEB
winning.church

CPSIA information can be obtained
at www.ICGtesting.com
Printed in the USA
FSHW020253030220